IMAGES
of America

LEIMERT PARK

Welcome Home!

Love,

Damon & Regina

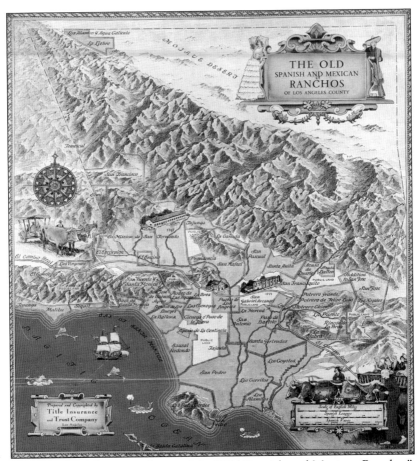

This is a photograph of the original map of the "Old Spanish and Mexican Ranchos" prepared by the Title Insurance and Trust Company in 1919. Rancho Cienega O'Paso de la Tijera is the original name of the land that now occupies Baldwin Hills, Beverly Hills, and Leimert Park. The Spanish name is two names combined: *La Cienega* or "The Swamp" refers to the marshes in the area between Baldwin Hills and Beverly Hills. The last part of the name, *Paso de la Tijera*, translates as "Pass of the Scissors"—to the early Spanish settlers, this pass resembled an open pair of scissors. This vast land was primarily used for raising cattle. Because the land had been unclaimed for many years following the first Spanish settlements in California, squatters had begun to build structures. As a result, the adobe of La Tijera, as it was called for short, was built by people who believed the land to be public. The exact date the adobe was built is unknown but believed to be as early as 1790 or 1795. Rancho o Paso de la Tijera is located south of the pueblo of Los Angeles in this illustration. (Courtesy of USC Special Collections, Doheny Memorial Library.)

ON THE COVER: This 1928 image shows the now-completed Leimert Square up close with a water fountain surrounded by manicured shrubbery, roses, and palm trees. Leimert Square, or Leimert Plaza as it later became known, is 110 feet by 228 feet in size. It was designed to be one of the "most beautiful spots in the city," as described in the Walter H. Leimert Company advertisements of the time. The Leimert Park Business Center house, seen faintly in the background, is photographed behind the park. A sign to the right warns "please keep off grass." (Courtesy of USC Special Collections, Doheny Memorial Library.)

IMAGES
of America

LEIMERT PARK

Cynthia E. Exum and Maty Guiza-Leimert
with a foreword by Walter H. Leimert III

ARCADIA
PUBLISHING

Published by Arcadia Publishing
Charleston, South Carolina

Printed in the United States of America

Library of Congress Control Number: 2012936585

For all general information, please contact Arcadia Publishing:
Telephone 843-853-2070
Fax 843-853-0044
E-mail sales@arcadiapublishing.com
For customer service and orders:
Toll-Free 1-888-313-2665

Visit us on the Internet at www.arcadiapublishing.com

*This book is dedicated
to Joyce Sumbi, devoted
friend and colleague, whose
unwavering support and
encouragement helped make
this publication possible.
Your spirit lives within these
pages, and we will forever be
grateful for your inspiration.*

CONTENTS

ACKNOWLEDGMENTS

Many individuals and institutions assisted us in the completion of this publication. We acknowledge them here with sincere appreciation and apologize to any we may have inadvertently omitted.

Thank you to Clint Rosemond, Ernest Dillihay, David Miller, and Dr. Genevieve Shepherd for their input and guidance, and to the late Joyce Sumbi who championed this project. Thank you to Kim Neelley, at KIMAGING, Inc., for processing Leimert archival images.

We express gratitude to Matthew Barrett and Neil Bjornsen, Archives of the Los Angeles County Metropolitan Transportation Authority; Michelle Welsing, Southern California Library for Social Studies and Research; Suzanne Oatey, Huntington Library; R. Kent Kirkton, Institute for Arts and Media, CSUN; Michael Salmon, LA84 Foundation; Leah Kerr and Larry Earl, Mayme A. Clayton Library and Museum; Rose Mitchell, A.C. Billbrew Library, Black Resource Center; Kathleen Correia, California State Library, California History Section; Paul Soifer and Angela Tatum, Historical Records Program, Los Angeles Department of Water and Power; Pamela Quon and Terri Garst, Los Angeles Public Library; Michael J. Dosch, National Park Service, Frederick Law Olmsted National Site; Jane Nakasako, Japanese American National Museum, Hirasaki National Resource Center; Dace Taube and Rachelle B. Smith, University of Southern California, Doheny Library Special Collections; UCLA Department of Geography, Spence Air Collection; and Los Angeles City and County Archives, with special thanks to Michael Holland, David Chin, Phillip Martinez and Jackie Calvin.

To private collectors, photographers, and archivists Alonzo Davis, Dale Davis, Halvor Thomas Miller, Jr., Kwame Cooper, Tony Gieske, Billie Frierson, Matt Gibson, Tiamoyo Karenga, Brian Minami, Malcolm Ali, Sabir Majeed, Mercedes Reilly and Oliver Hearn for loaning us their images.

To the many photographs and stories shared with us by members of the community including: merchants Ben Caldwell, Mary Kimbrough, Jackie Ryan, Alden Kimbrough, James Fugate, Tom Hamilton, Martin Manrique, Laura Hendrix, Angie and Chino Bravo; all members of the Cherrywood/Leimert Block Club especially Anna Burns, Thelma Baldwin, Ruth Spencer, Cheryl Key and Bill Webb; and the Leimert Park Village Merchants Association.

To the Leimert Investment Company for providing the bulk of our archival images as well as sponsoring our project's acquisition requests.

To our editors Amy Perryman and Elizabeth Bray at Arcadia Publishing. To our research assistants, Krysten Adair and Jason Collins. To our readers, Dr. Greg Hise, Robert C. Farrell, James V. Burks, Mel Assagai, Peter Harris, Erin Aubry Kaplan, Eric Gordon, Vanessa Cain, Steven, and Jeannette Isoardi for their valuable input as well as our editors, Cynthia Gibson and Amaechina Doreen Haywood.

Cynthia thanks her beautiful mom, Margaret Thompson, and wonderful friend Arthur Williams for their steadfast encouragement. Maty thanks her daughter, Saramarie, and husband, Walter, as well as Zuzanna Mackiewicz for encouraging her as cowriter; to Norman, Nicholas, Harry, and Max: may the history not be forgotten; and to the people and community of Leimert Park who regard Leimert Park as a special place: may the feeling of "home" live here forever.

FOREWORD

For over 85 years and spanning over three generations, our family-owned Leimert Company has prided itself with Leimert Park. It is the host to gatherings of all kinds: celebrations of music and culture, an annual book fair, political rallies, vigils, parades, and more. Thanks to the pioneering efforts of individuals that sought to bring focus to the African American culture, Leimert Park now has a palpable identity in Los Angeles that is far deeper than winding streets or Monterey-style homes.

Careful thought went into the planning and developing. The finest builders, contractors, and architects took place in making Leimert Park unlike no other. However, it is important not to forget that times were difficult and there were challenges. In its inception, Leimert Park's residents were mainly Anglo, and homeownership was not equally attainable to ethnic or minority groups. Today, Leimert Park is a predominantly African American community and at the center of African American culture; the area enjoys the recognition of having more than one Historic Cultural Landmark within its boundaries. Through all of these changes and challenges of the past, we continue to see the uniqueness of this small town and remain enthusiastic for the modern-day history that continues. If anyone knows how special Leimert Park is, we do.

Cynthia Exum's in-depth understanding of Crenshaw District history, her involvement with Leimert Park as founder of the Leimert Park Village Book Fair, and her studies in urban planning touch on the makings of Leimert Park culture. Maty Guiza-Leimert brings extensive research from the private archives of the Walter H. Leimert developments throughout California along with personal understanding of the importance of Leimert Park to our history. From ground-breaking to ribbon cutting, the story can be told dating back over 100 years. Together, these authors have put together the first pictorial book about Leimert Park history.

I am honored to have this opportunity to thank the residents, merchants, and those who have enjoyed Leimert Park through the years. Thank you for making Leimert Park so special to be a part of. I welcome the reader to travel through the journey that has been paved for us to explore.

—Walter H. Leimert III

INTRODUCTION

Images of America: *Leimert Park* tells the history of one of Los Angeles' most iconic and legendary sections. Through photographic images, the rich, diverse, complex, and sometimes challenging history of Leimert Park is revealed. Many of the photographs seen in *Leimert Park* are part of the private collection of Walter H. Leimert and have never before been published. And while we uncovered many wonderful photographs and images of this historic area, many more could not be included because of space limitations. With the selection of these unique images, we have woven the tale of Leimert Park from its humble beginnings in the late 1920s to its rise in the 1940s, its role in abolishing discriminatory housing legislation and the civil rights struggle in the 1960s, its place as the center of the jazz scene in the 1970s and 1980s, its rise as a mecca for African American–owned businesses, and its current landmark status as place where it all began.

The land was once a portion of the Rancho Cienega O'Paso de la Tijera, owned first by the Sanchez family, then by the Baldwin family. The first chapter, called "Rancho Cienega O'Paso de la Tijera," shows the underdeveloped land owned by the Sanchez family. E.J. Baldwin purchased the property and retained it until his death in 1909.

The second chapter, "Visions of Planning," shows how Walter H. Leimert purchased the property for $2 million from Clara Baldwin Stocker in 1927. According to a *Los Angeles Times* article, this transaction represented the largest purchase to date in Los Angeles. Leimert's vision for the planning and development of Leimert Park is laid out in chapter three, "Paving the Way." In this chapter, we see the faces of the builders, architects, and contractors who established Leimert Park. With building completed, the development was ready for sale. In chapter four, "Leimert Park for Living," a community unfolds as transportation, recreation, churches, and schools are centered around Leimert Park homes.

In chapter five, "Olympic Village," the area was bursting with activity and excitement as the city of Los Angeles hosted the 1932 Summer Olympic Games. The 1932 Olympics brought attention and an opportunity to showcase the area and the homes not only to the city but also to the world. The Baldwin Hills area is the site of the first Olympic village, and Sunset Fields Golf Course is the site for the Olympic pentathlon.

Chapter six, "Post–World War II Development," covers changes that occurred in Leimert Park in the 1940s and 1950s. Chapter seven, "Birth of a Village," covers the founding of the Brockman Gallery on Degnan Boulevard. Chapter eight, "Tour of Historical and Cultural Landmarks," walks us through an era in time as Los Angeles would be the home to visionaries such as Howard Hughes. The joint venture with Walter H. Leimert, known as the Leimert Theatre, still stands today. Chapter nine, "People, Places, and Community Celebrations," depicts how over time, Leimert Park has become a place to rally change (political or otherwise) and celebrate life events such as weddings and vigils, as well as art and book fairs and many other notorious celebrations. Chapter 10, "The Future of Leimert Park," is an eye-opening reality of the financial constraint affecting parts of Los Angeles.

In 1927, Walter H. Leimert, a wealthy real estate developer from Northern California, commissioned Olmsted and Olmsted to assist with the development of one of Los Angeles's first planned communities. Olmsted and Olmsted was a highly revered landscaped architectural firm owned by sons of Frederick Olmsted, the famous architect and master planner of New York City's Central Park.

Leimert Park had the ideal elements: thriving community, transportation, employment opportunities, recreation, and natural resources. The development was established in two phases,

the first in 1927 and the second in 1933 with the additional purchase of land. Pres. Frank Delano Roosevelt's New Deal National Housing Act of 1934 created the Federal Housing Administration (FHA) to insure bank mortgages. These mortgages were often for 20 to 30 years and at a down payment of only 10 percent. Homes in Leimert Park were insured by the FHA, making it easier to purchase a home there. Initially, residential ownership developments throughout the nation contained racial restrictions written into property deeds that excluded minorities and ethnic groups. Leimert Park was restricted to white residents until the restrictive covenants were struck down by the US Supreme Court in 1948. This landmark ruling came into effect in the entire United States. Nonetheless, even with the lifting of such covenants, homeownership in Leimert Park and areas like it was very difficult, as times had not yet changed the ways of the people.

Leimert Park experienced a demographic shift as a result of real estate intermediaries that would purchase property or lots on behalf of African Americans or other ethnic groups, such as Japanese Americans.

Leimert Park was an attractive community because of its modern style and affordability but also because of its proximity to Hollywood and downtown Los Angeles. Ella Fitzgerald, Ray Charles, Mayor Tom Bradley, financial industry executives, and other notables lived in Leimert Park for this reason.

Another significant milestone in Leimert Park's history included the 1965 Watts Riots. The event did much to scare earlier Leimert Park residents into migrating, creating housing and business opportunities for minority and ethnic groups.

Gradually, the area and especially parts of Leimert Park would become an oasis of African American art, music, and culture. The area began its present black renaissance with the arrival of art impresario Alonzo Davis shortly after the Watts Riots. Founded in 1967, Davis's Brockman Gallery (no longer in operation) nurtured the early careers of respected artists.

Over time, the Leimert Park Village would become the primary Afrocentric shopping district in Los Angeles. The village is located on a one square block bordered by Crenshaw Boulevard, Leimert Boulevard, and Forty-third Place with two-story Mediterranean-style buildings running through its center block. Leimert Park itself is a triangular park at Forty-third Place. Filmmaker John Singleton likens the village to the character and charm of Greenwich Village. During the late 1970s and early 1980s, Leimert Park was much like Harlem's golden era: jazz clubs, art galleries, and museums proliferated; Ella Fitzgerald and Ray Charles lived in the neighborhood; and numerous celebrated poets and musicians frequented both the village and the park. The late comedian Robin Harris became a household name performing in Leimert Park.

The area today is struggling to maintain its identify. Rising rents and redevelopment plans slated for the area have forced many businesses to close.

The Leimert Park sign is located at the intersection of Leimert Park Boulevard on West Martin Luther King Boulevard in what is known as Joyce Perkins Parkway for her contribution as cofounder and director of the Los Angeles Neighborhood Initiative.

One

RANCHO CIENEGA O'PASO DE LA TIJERA

At the time of the rancho, California was under Spanish rule and was named Alta California. Spanish rule over "New Spain," as Mexico (including Alta California) was called, ended in 1821. In 1843, Manuel Micheltorena, the Mexican governor of Alta California, granted the land to Vicente Sanchez, who upon his death left Rancho La Tijera to his son Tomas and his two daughters, Dolores and Maria. Like his father, Tomas was involved in civil service and was listed as tax collector. He also served in the Mexican-American War. Tomas, along with Gen. Andres Pico, formed the first organized police force in Los Angeles, known as City Guards, to protect the city from the growing tensions between the Anglo Americans and Mexican Americans, followed by bandito pursuits and captures. Tomas Sanchez was sheriff of Los Angeles from 1860 to 1867. (Courtesy of USC Special Collections, Doheny Memorial Library.)

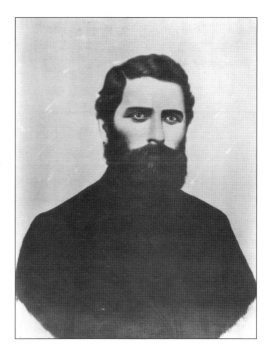

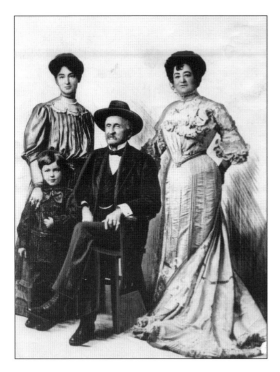

Pictured are four generations of the Baldwin family. Elias Jackson "Lucky" Baldwin (center) is surrounded by his granddaughter Rosebudd Doble Mullender (standing left), his great-grandson Joseph Mullender (front left), and daughter Clara Baldwin Stocker (standing right). (Courtesy of Los Angeles Public Library photograph collection.)

On January 6, 1927, eighteen years after Baldwin's death, Clara accepted the acquisition of 231 acres of land for nearly $2 million by real estate developer Walter H. Leimert. The first phase of the subdivision of Rancho La Tijera, bounded to the north by Santa Barbara Boulevard, east to Arlington Avenue, south to Vernon Avenue, and west to Angeles Mesa Drive, was about to take place. (Courtesy of Leimert Investment Company.)

ACREAGE BRINGS MILLIONS

Clara Baldwin Stocker Sells Large Tract of City Land to W. H. Leimert, Realty Broker

One of the largest transfers of undeveloped property to take place in Los Angeles for some time was announced yesterday by Walter H. Leimert, local realty broker, who has purchased 231 acres of city property from Clara Baldwin Stocker.

The deal was consummated ten days ago and involved a consideration of approximately $2,000,000, Leimert declared.

CLARA BALDWIN STOCKER.

The property transferred is bounded on the north by Santa Barbara avenue, on the east by Arlington, on the south by Vernon avenue and on the west by Angeles Mesa Drive.

It is a portion of the estate inherited by Clara Baldwin Stocker from her father, E. J. (Lucky) Baldwin in 1909, and, together with some 3549 additional acres, it comprised one of the many ranch properties owned by the famous horseman, who took $20,000,000 in gold from the Comstock Lode mines of Virginia City, Nev.

This property has been held intact by Clara Baldwin Stocker since she inherited it and it has been in the Baldwin family for fifty-seven years.

The property is to be subdivided into a high-class residential district, according to the plans of the purchaser, who already has developed 1700 acres of Los Angeles property for the market. Plans for the subdivision have been prepared by Franz Herding, City Planning Engineer, Leimert said, and the actual improvement work is to begin immediately. The completed project will be known as "Leimert Park," it was said.

WALTER H. LEIMERT.

The history of the property bought

(Continued on Page 2, Column 3)

Two

Visions of Planning

Walter H. Leimert (1877–1970), photographed in 1920, was the eldest of 13 children born to Louis and Anna Leimert in Oakland, California. Leimert's parents were emigrants from Baden, Germany. Louis, a confectioner in Germany, had opened a candy store in Oakland and later became interested in commercial real estate. In 1874, Louis purchased what has come to be known as the Leimert Building in historic Old Oakland. In Los Angeles, Leimert envisioned growth and industrialization as large manufacturing companies were looking at the West Coast as a place to set satellite offices. A "work place dwelling" project could meet the demand that soon would happen on the land previously owned by Baldwin. (Courtesy of Leimert Investment Company.)

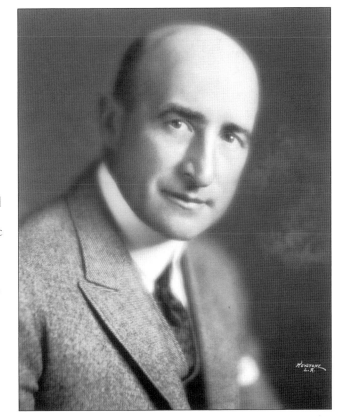

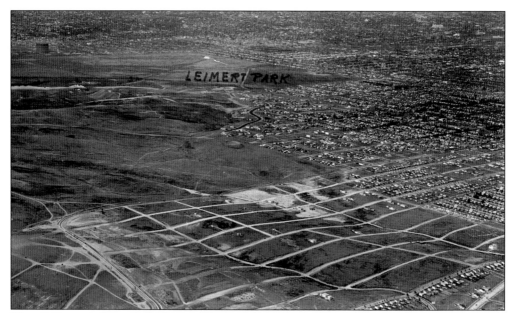

This 1927 aerial photograph shows undeveloped Rancho La Tijera land soon to be Leimert Park. (Courtesy of Leimert Investment Company.)

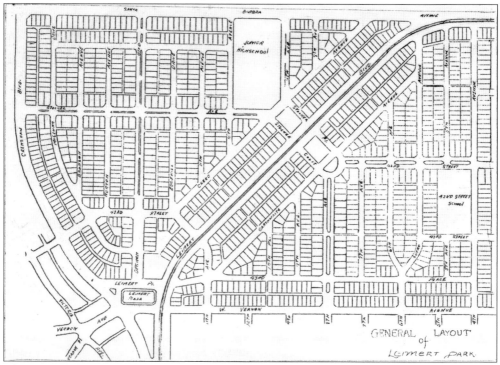

This general layout was imagined and studied by the Walter H. Leimert Company and its team of contractors, engineers, and consultants in 1928. Leimert Park was to be a "work place dwelling" project. As such, Leimert Park was to provide all of the elements required for upscale living at an affordable cost. Schools have been factored into the layout. (Courtesy of Leimert Investment Company.)

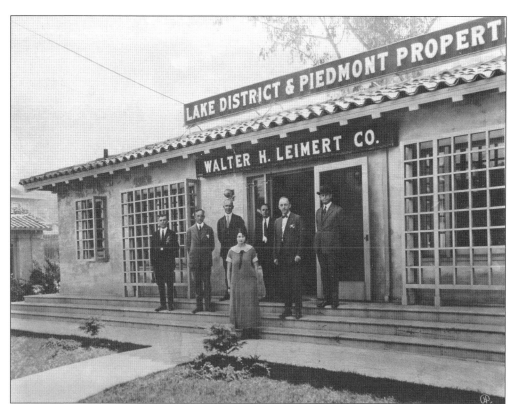

The Walter H. Leimert Company headquarters for the Lakeshore Highlands development is pictured around 1916. (Courtesy of Leimert Investment Company.)

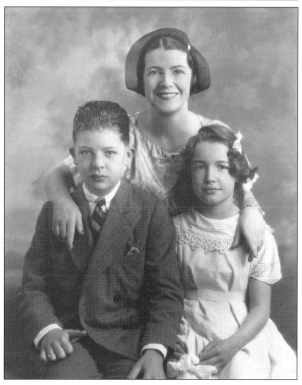

Lucille Leimert poses alongside son Walter "Tim" and daughter Patricia around 1935. After successful completion of the Lakeshore Highlands development, Leimert moved his wife, Lucille Cavanaugh, and his young children to Los Angeles, California. They were one of the first families to reside at the newly built Biltmore Hotel in downtown Los Angeles in 1923 while they built their home in Hancock Park. (Courtesy of Leimert Investment Company.)

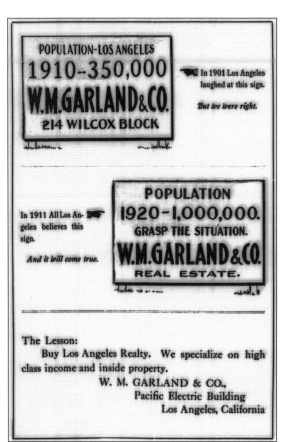

In 1915, William M. Garland & Company promoted Los Angeles as a place for real estate investing. The prediction of population growth had driven many developers like Walter H. Leimert to Los Angeles. Garland predicted the population in Los Angeles to be at one million by 1920. Garland was right; the population had immensely grown from approximately 5,000 in 1876 to more than 100,000 by the beginning of the 20th century. (Courtesy of USC Special Collections, Doheny Memorial Library.)

The Walter H. Leimert Company had already begun to develop other areas in Los Angeles—such as City Terrace—in the early 1920s. Walter H. Leimert knew that growth and demand for housing was a reality. The City Terrace headquarters for the Walter H. Leimert Company development were in a tent; behind the tent are rolling hills. (Courtesy of Leimert Investment Company.)

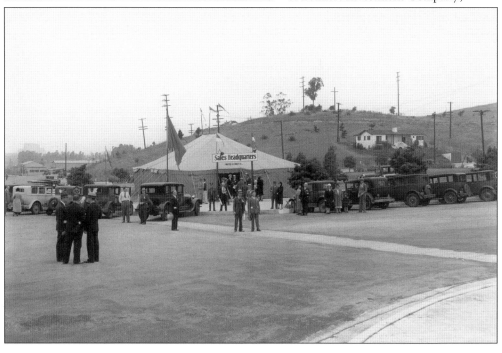

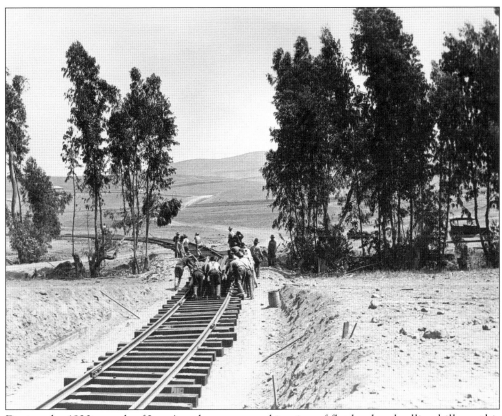

During the 1920s, much of Los Angeles was a combination of flat land and rolling hills, as this image demonstrates. Men are working on building a railway and haul steel on a carriage. (Courtesy of Leimert Investment Company.)

This 1927 Los Angeles Chamber of Commerce map details the many airports of that time. The map shows the locations of numerous airports within Los Angeles as small black circles with white airplanes. Some of the airports within the immediate vicinity of Leimert Park included Angeles Mesa Airport, located at 3801 Angeles Mesa Drive, and the American Airport, located at 3809 Crenshaw Boulevard. (Courtesy of USC Special Collections, Doheny Memorial Library.)

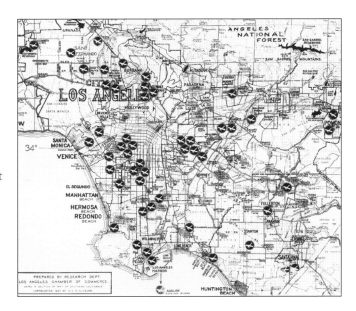

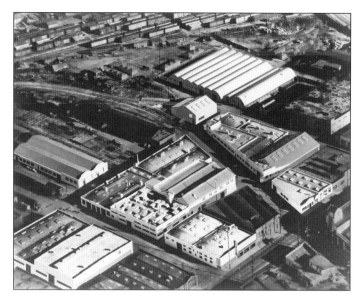

The Essick Company was a large manufacturer near downtown Los Angeles from 1910 to 1940. The various industrial buildings span over four blocks. A road extends from the lower right corner to the railroad tracks. This site was the parent to ranch plants in Arkansas and New Jersey and a subsidiary of T.L. Smith Company of Wisconsin and Texas and the Sterling Machinery Company, formerly of Missouri. (Courtesy of USC Special Collections, Doheny Memorial Library.)

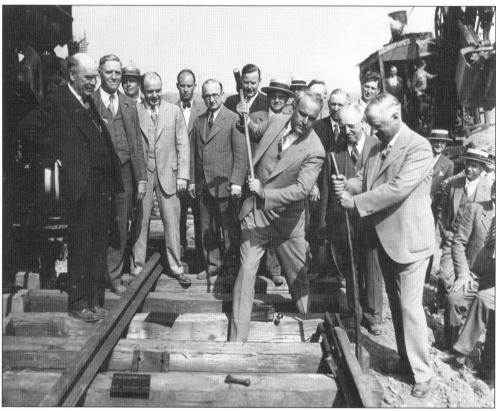

Willys-Overland was also celebrating its ground-breaking ceremony in 1925. The new branch plant in Los Angeles would boost industry and bring employment and a population growth to Los Angeles. (Courtesy of USC Special Collections, Doheny Memorial Library.)

Three

PAVING THE WAY

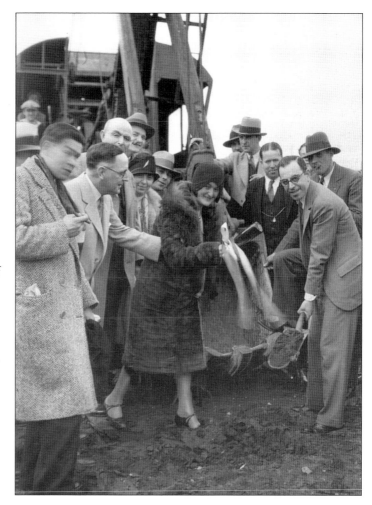

The early development of Leimert Park was a huge undertaking, involving the best in class with regards to construction and design. Pictured is the Leimert Park ground-breaking ceremony as the way is paved for what the Walter H. Leimert Company predicts to be the next "second largest sub-center in Los Angeles." (Courtesy of Leimert Investment Company.)

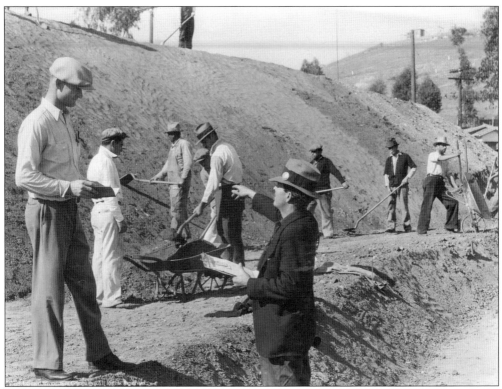

Many contractors were hired to work on the first phase of the Leimert Park tract. In this 1927 photograph, the Oswald Brothers, road paving contractors, work away with shovels and earth-moving equipment as they prepare the ground for road developments. The old Rancho La Tijera had not been paved for streets other than a railway that bisected the rancho. Many roads had to be built to service the development of new housing, schools, churches, and shopping centers as well as railway extensions into Leimert Park from downtown's Los Angeles Railway. The growth spurt was now taking place and shaping up a greater Los Angeles. (Both, courtesy of Leimert Investment Company.)

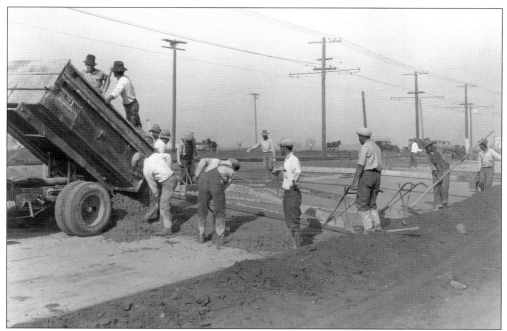

The Oswald Brothers continue to prepare and pave roads and sites for home building in 1928. Workers reflect a diverse crew as whites and blacks together start paving the way for all that is to occur in this tract of Leimert Park. Horses, which were used as working animals, are visible in the background. (Courtesy of Leimert Investment Company.)

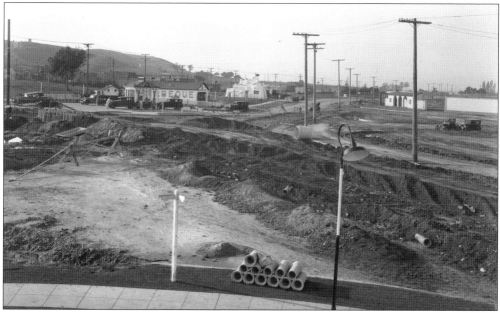

This 1927 photograph shows the few commercial businesses in the area immediately surrounding the Leimert Park development, including a few gas stations. A standalone building reads "Mesa Barbecue" with the slogan "the perfect beer on draught." An igloo advertises "fancy ice cream sandwiches." The creation of a community is underway. (Courtesy of USC Special Collections, Doheny Memorial Library.)

City Council
of the
City of Los Angeles
City Hall

L. R. RICE-WRAY
COUNCILMAN
SIXTH DISTRICT

COMMITTEES:
BUILDING AND SAFETY, CHAIRMAN
PUBLIC WORKS
TUNNELS, BRIDGES AND VIADUCTS

February 2, 1928.

Mr. Walter H. Leimert,
251 South Muirfield,
Los Angeles, California.

Dear Mr. Leimert:

The following report was adopted by the Council this morning:

"File #502(1928) Public Works Committee recommends that the recommendations of the City Engineer that the 25% petition for the improvement of Angeles Mesa Drive between Exposition Boulevard and Vernon Avenue be granted, be concurred in, and the City Engineer instructed to prepare plans and ordinances, in order to have at least a 70 ft. roadway throughout the length of the street."

Very truly yours,

L. R. RICE-WRAY
Councilman 6th District.

On February 2, 1928, Councilman L.R. Rice-Wray of the sixth district informs Walter H. Leimert that his petition for 25-percent improvement of Angeles Mesa Drive between Exposition Boulevard and Vernon Avenue is approved by the City of Los Angeles. Angeles Mesa extended from Adams Boulevard to Seventy-ninth Street and was renamed Crenshaw Boulevard on June 18, 1930, under City of Los Angeles Ordinance No. 66839. (Courtesy of Leimert Investment Company.)

Various streets were improved after 1927. A man assembles what will be a portion of Angeles Mesa Drive. On August 8, 1930, Leimert Boulevard was extended from Santa Barbara Boulevard (now Martin Luther King Jr. Boulevard) to Forty-sixth Street by City of Los Angeles Ordinance No. 67233. Portions of Leimert Boulevard extending from Vernon to Forty-sixth were renamed Crenshaw Boulevard. (Courtesy of USC Special Collections, Doheny Memorial Library.)

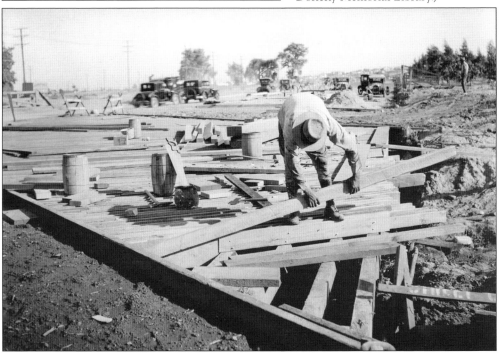

The Walter H. Leimert Company uses the best in class when it comes to architecture, construction, and landscape. The Olmsted Brothers, who designed and built many important sites, such as New York's Central Park, provide the layout of the landscape. This July 27, 1929, letter is one of many conversations made in connection to the request for creating Leimert Square. (Courtesy of Leimert Investment Company.)

8202

OLMSTED BROTHERS
LANDSCAPE ARCHITECTS
BROOKLINE · MASSACHUSETTS

FREDERICK LAW OLMSTED
JAMES FREDERICK DAWSON
PERCIVAL GALLAGHER
EDWARD CLARK WHITING
HENRY VINCENT HUBBARD

WESTERN OFFICE

TELEGRAMS
REDONDO BEACH
CALIFORNIA

PALOS VERDES ESTATES
CALIFORNIA

July 27th, 1929.

LEIMERT SQUARE

List of plans that were made in connection with your work

No. 2	Planting plan	paper	Jan. 25th, 1928
No. 3	Perspective Sketch	paper	Jan. 30th, 1928
No. 4	Detail for Sidewalks	cloth	Feb. 3d, 1928
No. 5	Plaza Pool, full size details of Moulding	paper	Feb. 17th, 1928
No. 6	Perspective Sketch (revision of No.3) Entire Square		Feb. 11th, 1928
No. 7	Details for Fountain Garden	paper	July 11th, 1928

Leimert Park's plaza fountain is under construction and readily identifiable by the freshly planted palm trees. The area designated as Leimert Park Plaza and sometimes referred to as Leimert Square is clearly underway. Vernon Avenue is in the process of being paved while Bates and Borland Contractors are busy at work. (Courtesy of Leimert Investment Company.)

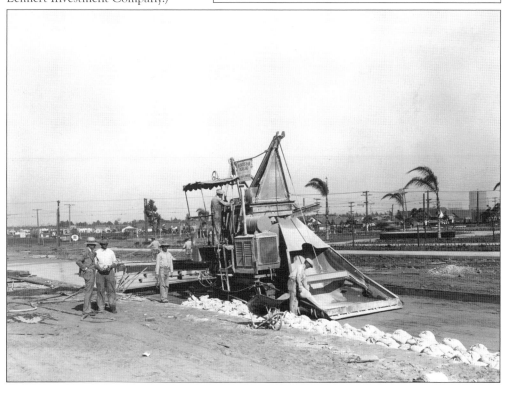

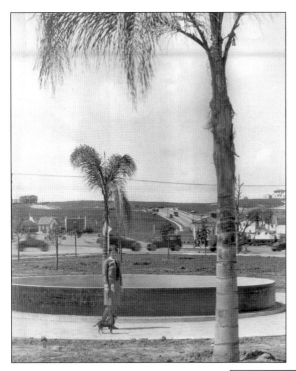

A woman and her dog walk along the construction site of the Leimert Park Plaza, which will include a fountain in the middle of the circle. The only landscape in the area continues to be the palm trees as the major thoroughfare of Angeles Mesa/Crenshaw Boulevard shows some traffic moving in the background. The rolling hills of the rancho are still visible amongst a sparse development. (Courtesy of Leimert Investment Company.)

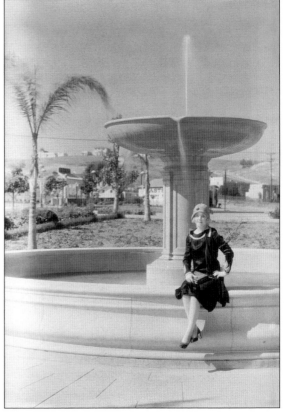

The 1928 completion of Leimert Park Plaza is followed by immediate publicity. Pictured is silent film star Wanda Hawley posing atop the newly built fountain. The fully operational fountain is also landscaped in 1928. To date, this fountain's style and design are the same as they were in its inception. (Courtesy of USC Special Collections, Doheny Memorial Library.)

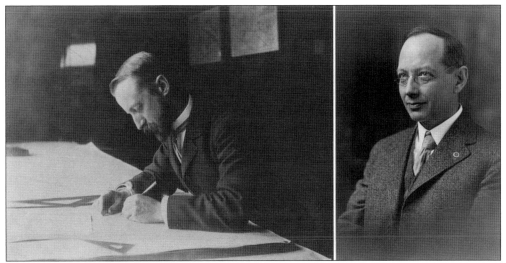

In 1927, Walter H. Leimert commissioned Olmsted and Olmsted to assist with the development and design layout of Leimert Park. Olmsted and Olmsted was a highly revered national landscape architectural firm. They were sons of Frederick Olmsted, the famous architect and master planner of New York City's Central Park. Frederick Law Jr. is pictured at left (1870–1957) with John Charles pictured at right (1852–1920). (Courtesy of the National Park Service/ Frederick Olmsted National Historical Site.)

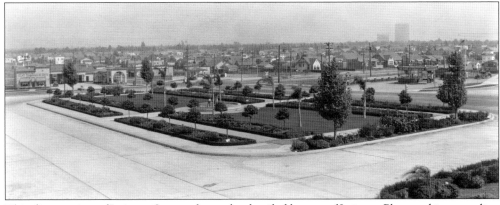

This distant view of Leimert Square shows the detailed beauty of Leimert Plaza and its cascading water fountain and ground landscaping while showcasing the aesthetics of the residential community underway. An unidentified gentleman is seen enjoying the park's setting with a "Homes for Sale" sign positioned to his right. (Courtesy of the Huntington Library, San Marino, California.)

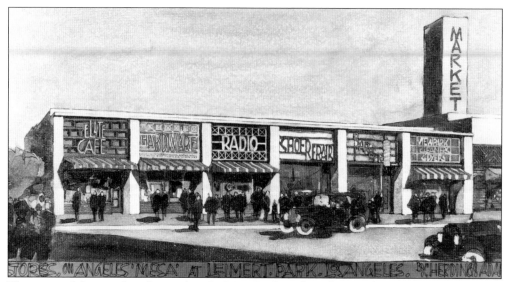

The proposed shops and market on Angeles Mesa Boulevard are illustrated in this sketch by Herding & Adams. The Mesa-Vernon Market would be the start of the largest center south of downtown and east of West Los Angeles. A barbershop, market, café, hardware store, dry cleaners, and radio station were envisioned. (Sketch by Herding & Adams; courtesy of USC Special Collections, Doheny Memorial Library.)

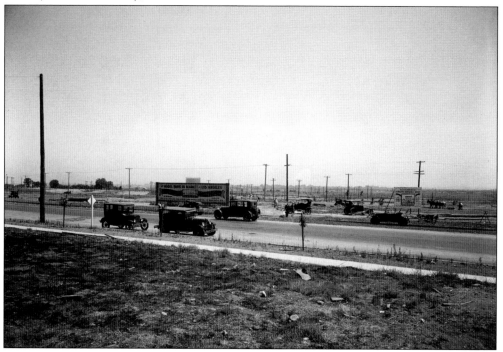

Angeles Mesa Boulevard is pictured in 1928, before the construction of the "Model Drive-In Market of Los Angeles." A second sign advertises that Pacific National Bank has purchased the land and a branch is to be built "at once." During this time, horses were still used as working animals. On June 18, 1930, Angeles Mesa was renamed Crenshaw Boulevard by Los Angeles City Ordinance No. 66639. (Courtesy of USC Special Collections, Doheny Memorial Library.)

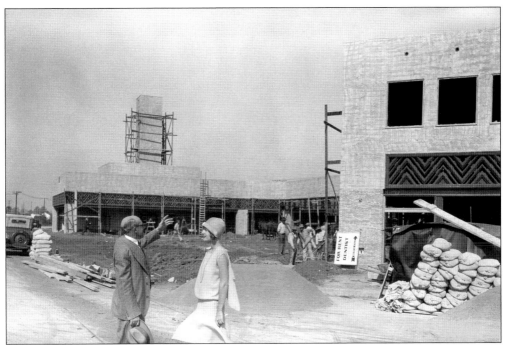

A gentleman and a fashionably dressed woman discuss the construction of the Mesa-Vernon Market in 1928 as workers look at them while being photographed. Men are at work with scaffolds, shovels, and horses on the grounds of the soon-to-be market. A sign advertises a dentist's office for rent. (Courtesy of USC Special Collections, Doheny Memorial Library.)

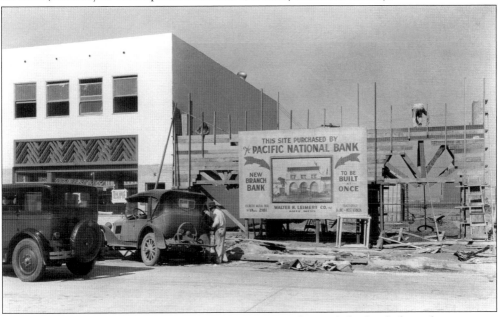

The concurrent construction of the Mesa-Vernon Market and the bank drew the attention of professionals who sought to enjoy the amenities that Leimert Park could offer. Soon after, merchants such as florists, butchers, dentists, doctors, and others began to occupy the shops along the market environs. (Courtesy of Leimert Investment Company.)

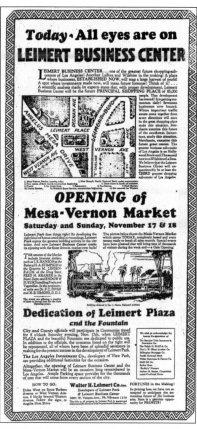

On November 17, 1928, the Mesa-Vernon Market and Fountain Café opened their doors for the first time. Patrons could enjoy groceries, shop for gifts, and visit the dentist, the surgeon, or the pharmacist. The Walter H. Leimert Company advertised in all local newspapers. Here, all eyes are on Leimert as the first open-air market is opened.

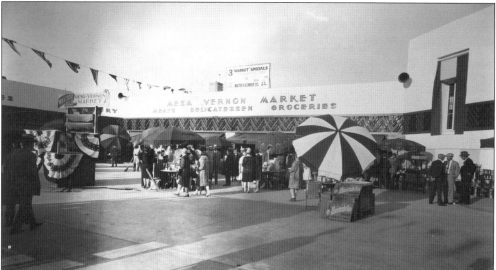

The Mesa-Vernon Market grand opening showcases the residential development tract and lists a "3 Market Special" during its first days. This special lists lots at lower-than-usual prices of $3,450, $7,450, and $9,450 depending on square footage. The sign reads "Welcome to the South West" as banners decorate the buildings and rooftops. (Courtesy of USC Special Collections, Doheny Memorial Library.)

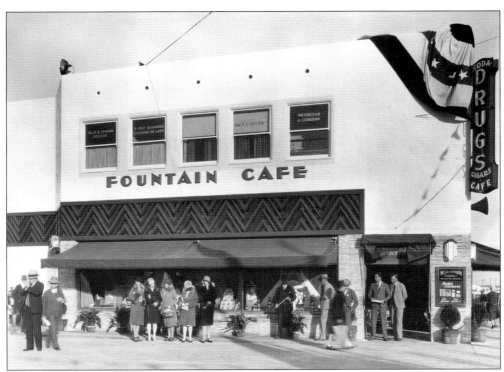

Adjacent to the Mesa-Vernon Market was the Fountain Café and Mesa Vernon Pharmacy. Atop the Fountain Café were the offices of Dr. H.B. Simmons, dentist, and Dr. F.C. Diver, physician and surgeon. Patrons were offered the convenience of living in a planned community with the amenities required for everyday life. (Courtesy of Leimert Investment Company.)

This 1932 photograph shows the Woman's Wear Shop, which was located within the Mesa-Vernon Market and was one of the proposed shops in the original sketch of the Angeles Mesa market. Elegant wear is displayed throughout this elaborately decorated store. (Courtesy of Leimert Investment Company and compliments of Mary Wiley E.)

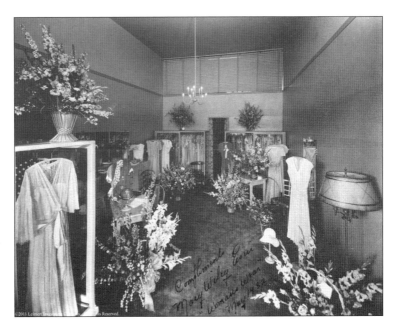

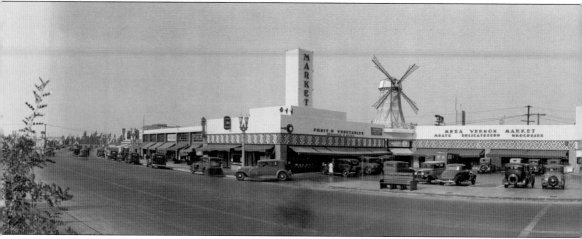

March 29, 1930, brought another celebration to Leimert Park, advertised as a "Spanish Fiesta" featuring vaudeville acts, music, movie stars, and more. This time, Citizens National Bank displays its celebration banners across the Mesa-Vernon Market. The market is in full operation in 1930, and Leimert Park's thoroughfares are populated with traffic, traffic signals, and a street guard. Lining the major streets are gas stations, restaurants, and the ice cream igloo, which remains

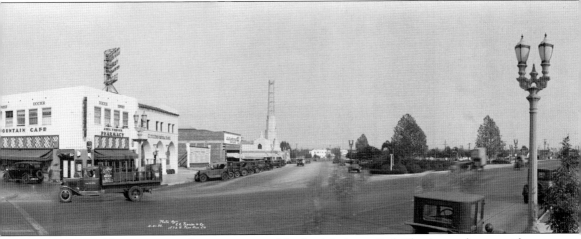

in its original location since the acquisition of the land. Leimert Park Plaza's grandeur provides an impressive appeal to the community at large, while the trademark Leimert development arrows point to more construction sites, which would include a theater and a village, places that would later become landmarks in the community. (Courtesy of the Huntington Library, San Marino, California.)

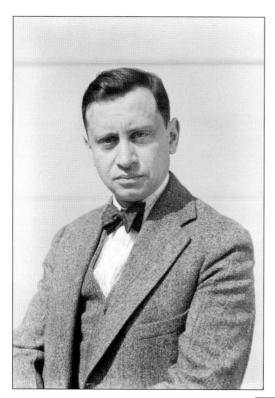

Dr. M. Lindenbaum was one of the first merchants and dentists to serve Leimert Park. Though there were many merchants and shops in the Mesa-Vernon Market only a few were recorded and photographed for the Walter H. Leimert Company publicity shots. (Courtesy of USC Special Collections, Doheny Memorial Library.)

This Japanese American gentleman is unidentified, but in the 1930s, he was one of the first tenants at the Mesa-Vernon Market. Company archives and local newspapers indicate that he may have been affiliated with either the florist or the vegetable grocer, both of which were of Japanese descent and listed in advertisements by the Walter H. Leimert Company. (Courtesy of USC Special Collections, Doheny Memorial Library.)

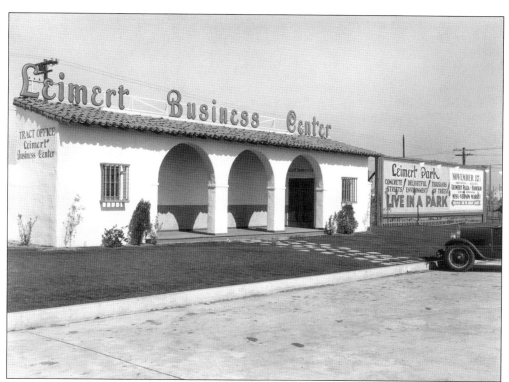

The Leimert Business Center and Administration Headquarters were located within this structure on West Vernon Street. A large sign reads "Live in a Park" and encourages the public to inquire within. This tract office was used for the sales of the first phase of the residential development and the construction and leasing of the shops at the Mesa-Vernon Market. (Courtesy of Leimert Investment Company.)

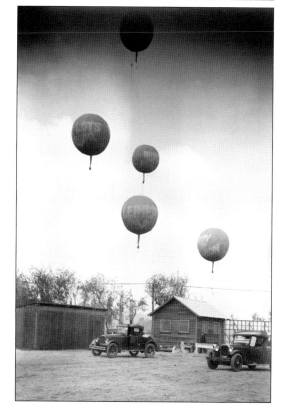

Large balloons are visible in the sky immediately above the Leimert Park tract office and for miles away. This form of advertising attracts the attention of motorists in neighboring areas and brings people to the new homes in Leimert Park. The balloons read "Lots for Sale," "Business Income," "Leimert Park," and "Buy Now." (Courtesy of USC Special Collections, Doheny Memorial Library.)

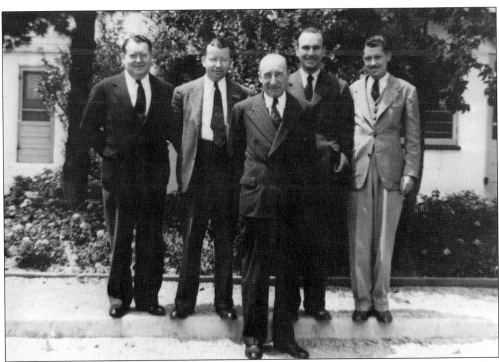

Walter H. Leimert, founder and owner of the Walter H. Leimert Company, is photographed at center with his sales staff outside of the Leimert Business Center. Below are the Walter H. Leimert Company sales agents and staff outside of the same location. A small number of the agents invested in the development and later became officers and partners of the company. Some of these early partners of the Walter H. Leimert Company have remained partners (through second and third generations) in other developments and investments of the Walter H. Leimert Company since Leimert Park's inception. (Both, courtesy of Leimert Investment Company.)

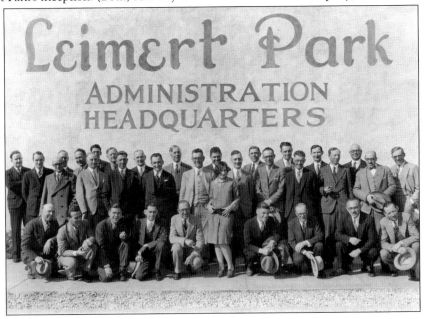

Four

LEIMERT PARK FOR LIVING

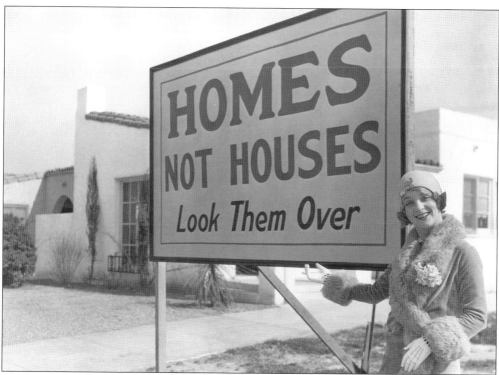

The establishment of Leimert Park as a community where one could have "home, income, investment and convenience" was paramount to Walter H. Leimert. Here, his company advertises new residences in a park-like community as "Homes not Houses," a sentiment that would last for decades to come for Leimert Park homes. (Courtesy of Leimert Investment Company.)

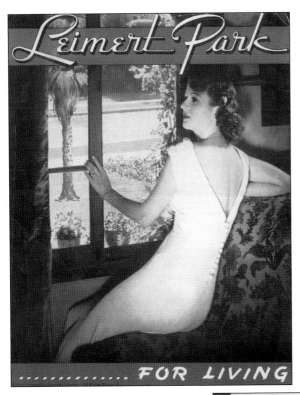

Leimert Park homes were vastly advertised by the Walter H. Leimert Company as the perfect choice for living. In Leimert Park, one could have "home, income, investment and convenience." Leimert Park has everything and has grown from a field of beans and hay to one of the largest independent communities within the metropolitan area. (Courtesy of Leimert Investment Company.)

The interior of the "Leimert Park for Living" brochure describes the "magic circle" as the six-mile radius and only 15 minutes away from downtown Los Angeles, the central manufacturing district, Santa Monica Bay beaches, south coast beaches, Culver City, Hollywood, Beverly Hills, and the Westwood studios. (Courtesy of Leimert Investment Company.)

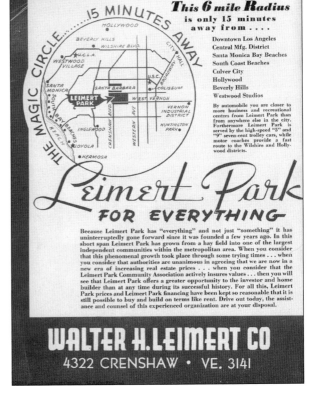

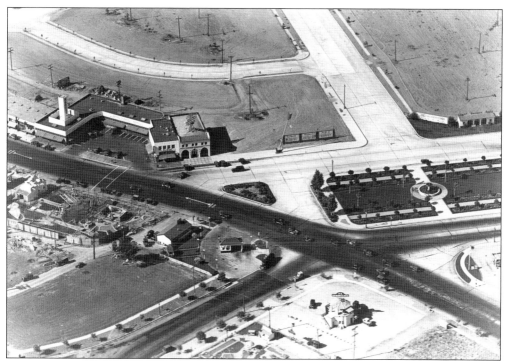

Degnan Boulevard awaits development while vehicles can be seen along a busy Crenshaw Boulevard. This August 19, 1930, Spence aerial photograph shows the newly developed land around the Leimert Park area. Angeles Mese-Vernon Market and the Leimert Park Plaza are now visible and enticing new homeowners and visitors. (UCLA Department of Geography, The Benjamin and Gladys Thomas Air Photo Archives.)

In another aerial captured by Spence Air Photographs on September 29, 1936, Leimert Park has grown to include a theater and a business center on Forty-Third Place and Degnan Boulevard, and a popular bakery with its trademark windmill now occupies the Mesa-Vernon Market. In nine years, Leimert Park has gone through rapid growth despite a very weak economy. (UCLA Department of Geography, The Benjamin and Gladys Thomas Air Photo Archives.)

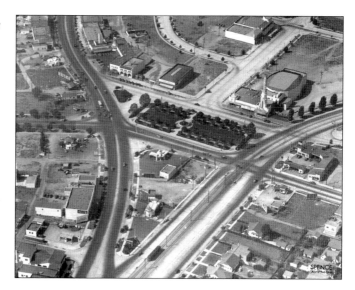

This 1929 publicity photograph depicts a middle-class woman. In this year, many publicity shots were used depicting models and well-known actors and actresses. As Leimert Park predominantly catered to the Anglo population due to ethnic and minority restrictions on developments, most of the advertisements of the time reflected young women and children, as in the publicity photograph below. Leimert Park was a great community to grow a family in, as grade schools were within the parameters of the residential tracts. Both homes photographed are of the traditional Spanish Revival architecture that the Walter H. Leimert Company favored throughout Leimert Park and other Los Angeles developments. (Both, courtesy of Leimert Investment Company.)

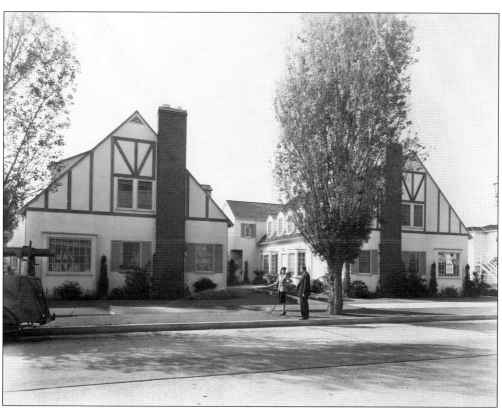

On September 1, 1933, the Baldwin heirs sold to West Side Land Company, a subsidiary of the Walter H. Leimert Company, in what was considered one of the largest turnovers of unimproved land since 1930. The property consisted of a half-mile frontage on Crenshaw Boulevard and Santa Barbara and Ninth Avenues and would be an addition to the Leimert Park development. The Federal Housing Administration (FHA) was created in 1934 as part of Pres. Franklin D. Roosevelt's plan to encourage residential construction, repair, and modernization by insuring loans and mortgages. Many banks had failed, and many mortgages were foreclosed on. This new way of financing would enable affordable homeownership in Leimert Park, as these homes were FHA approved. The Somerset Home, a two-bedroom, two-bath FHA home, is featured in this advertisement and publicity photograph. (Courtesy of Leimert Investment Company.)

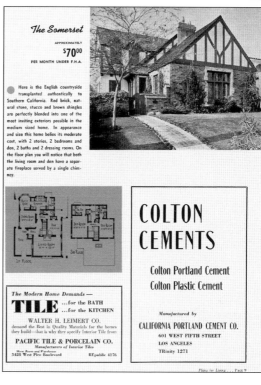

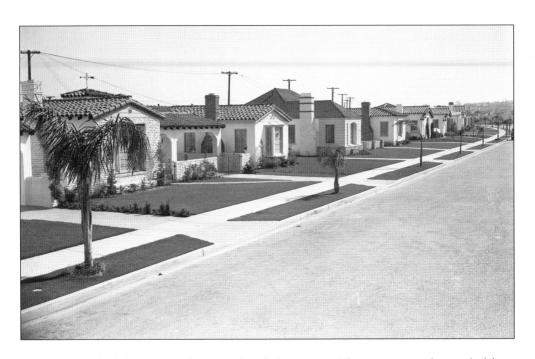

A row of newly built homes is on display and ready for move in. The attractive curb appeal of these homes made for comfortable modern-day living in the 1930s. Walter H. Leimert wrote a section in the brochure titled "Plans for Performance" in which specific homes were featured. Leimert elaborated that the homes had not been selected for their "modernity" but rather "livability." Leimert added that the homes have "stood the test of time" and they provided "comfort and contentment day in and out." A much-coveted home, used on the cover of *Life* magazine, was located at 3892 Tenth Avenue in Leimert Park. The home was designed by H. Roy Kelley and furnished by May Co. The homes were designed for a family with an income of $3,000 to $4,000. Payments for FHA homes this brochure ranged from $41 to approximately $70 per month. (Both, courtesy of Leimert Investment Company.)

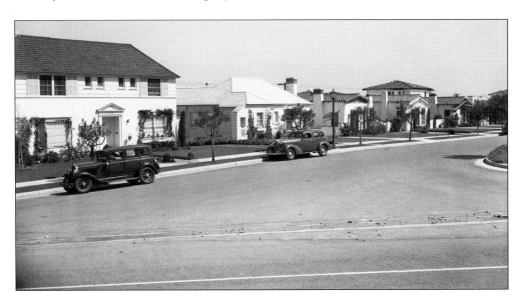

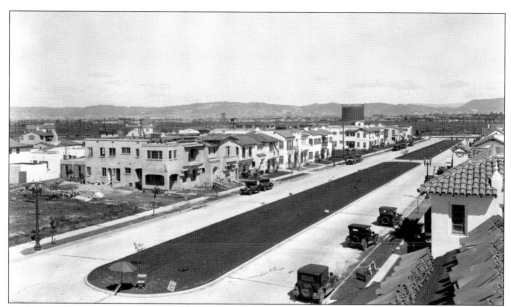

Multiple-family homes are under construction in 1929 on Second Avenue. The median is built and streetlights are installed, though trees have not yet been planted. Rows of these homes were built concurrently, and most reflected architecture similar to the single-family residences. Characteristic of these homes was the Spanish tiled roof, wrought-iron designs on windows or walls, white stucco, and arches, along with many windows and verandas, on the second story in some cases. Below, a sales agent for the Walter H. Leimert Company walks through the construction site as a masonry worker applies finishing touches to the exterior stairs. Affordability and return on investment were promoted as well; buyers could purchase investment income by way of a duplex—live in one, rent the other. (Above, courtesy of USC Special Collections, Doheny Memorial Library; below, courtesy of Leimert Investment Company.)

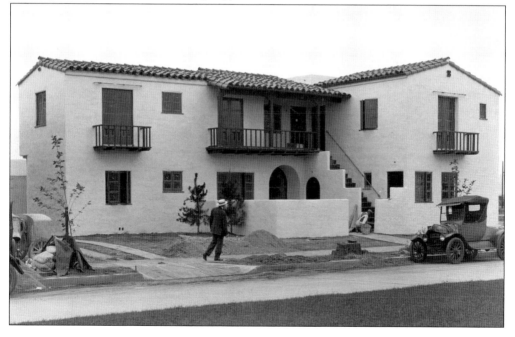

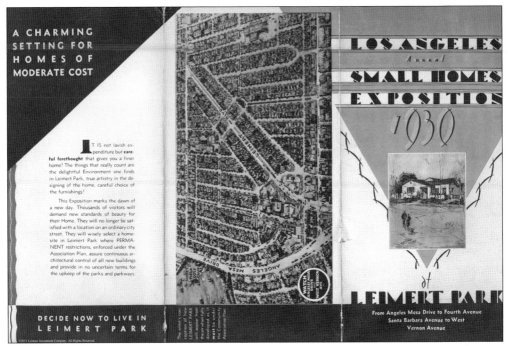

The 1930 Small Homes Exposition brochure created by the Walter H. Leimert Company features Leimert Park homes. The reasons why Leimert Park is the place to live are listed by Walter H. Leimert Company. The permanent restrictions enforced under the association plan assure continuous architectural control of all new buildings and provide in no uncertain terms for the upkeep for the parks and parkways. Contrary to common thought, restrictions were not only racial or ethnic. Deeds included restrictions against certain types of industry that might weaken the value of the homes. The concept of a homeowners' association was relatively new to Los Angeles and was seen as an obstacle as ethnic groups attempted to buy homes in Leimert Park. Even after the lifting of the covenants in the late 1940s, they were unable to get past the mindset of the association or of the people of Leimert Park for many years later. Leimert Park, however, enticed everyone as schools, golf courses, churches, and shopping centers surrounded this affordable middle-class community. (Both, courtesy of Leimert Investment Company.)

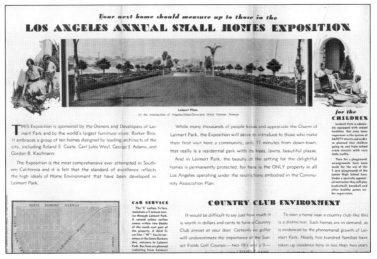

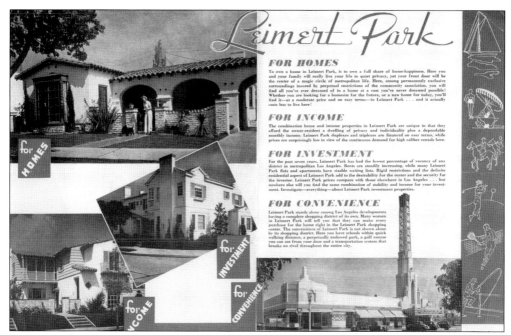

Leimert Park was a sound investment for all, as detailed in the advertisements of the 1930s. Here are specific reasons for why Leimert Park was for homes: quiet privacy at the front door of the magic circle of metropolitan life, referring to the six-mile radius of Leimert Park to neighboring metropolitan communities; unique combinations of owner-user dwellings of high caliber provided income in the duplexes and triplexes of this community, and the income generated by the rentals was secured in that the lowest vacancy rates were in Leimert Park with people on the waiting list for single-story homes; lastly, Leimert Park offered convenience, as it was a complete shopping district of its own, with a perpetually endowed park, schools within walking distance, and a golf course, and the image of the theater is sketched on the brochure. In addition, the Walter H. Leimert Company profusely promotes the schools, golf courses, and charm of the small home. (Both, courtesy of Leimert Investment Company.)

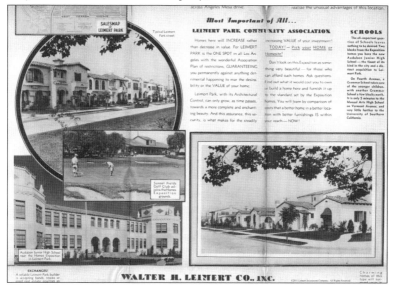

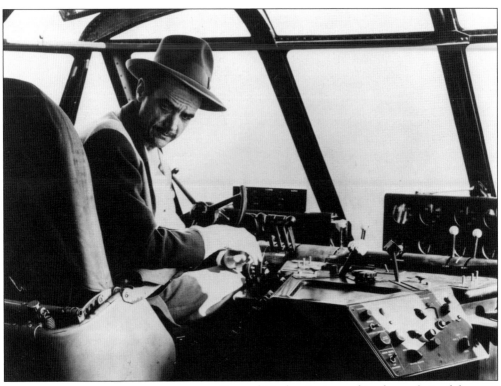

Howard Hughes is pictured in the cockpit of the "Spruce Goose." Hughes was only 25 years old when he joined Harold B. Franklin to form the Hughes-Franklin Theatre Group; the theater was designed for use by Hughes-Franklin. Hughes set his sights on building and designing, according to the *Los Angeles Times*, a theater that would be "one of the finest neighborhood showcases in the country." (Courtesy of Los Angeles Public Library photograph collection.)

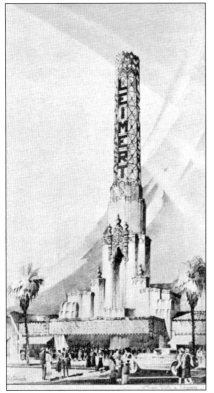

Always forward thinking, the Walter H. Leimert Company commissioned a sketch of one of the main attractions for recreation and entertainment in Leimert Park: the theater. The Walter H. Leimert Company advertised that the Leimert Business Center would be the "second most important sub-center in Los Angeles." Like many theaters in Los Angeles, the building would have a tower sign (pictured) to beckon motorists from long distances. (Courtesy of Leimert Investment Company.)

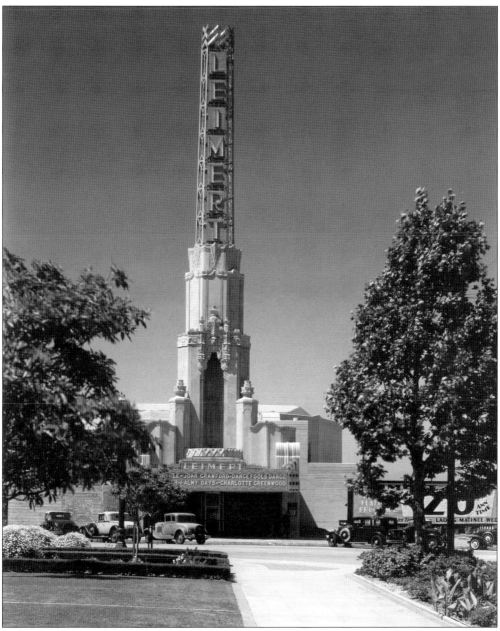

Built in 1931 in a joint venture between Walter H. Leimert and Howard Hughes, the Spanish-tinged Leimert Theatre has retained its importance to the community. It is one of the last two remaining great Art Deco theaters in Los Angeles. The exterior was designed by architect Stiles O. Clements of the firm Morgan, Walls & Clements, who designed other Los Angeles theaters such as Belasco, Mayan, and El Capitan Theatre No. 1. Clements was responsible for the architecture of the Merritt Huntley and Rhoda Rindge Adamson House in Malibu, the William Randolph Hearst Castle, and the Samson Tire and Rubber Company, along with many other impressive structures throughout Los Angeles. The Hughes–Franklin Theatre chain was short-lived. While a beautiful construction, the theater was unable to continue. The last movie shown was *Bonnie and Clyde* in 1968. (Courtesy of California State Library, History Room.)

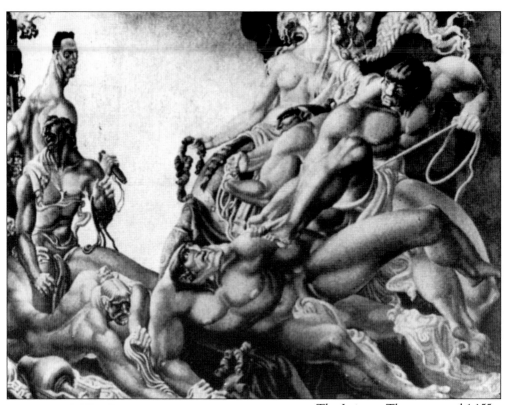

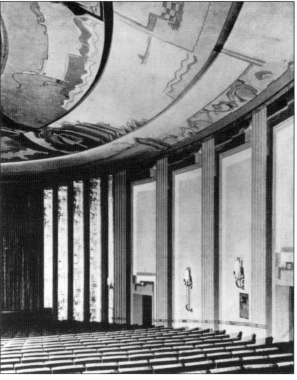

The Leimert Theatre seated 1,155, all in one level. The foundation permitted the construction of a 13-story addition, which did not occur as a result of the postwar decline. The lobby featured an extensive mural depicting Samson and Delilah by famous muralist Anthony Heinsbergen. The economic downturns such as the 1929 stock market crash and World War II had devastating impacts on Leimert Park. The theater and the merchant shops surrounding Leimert Park struggled to stay in business. Nonetheless, with the theater came birth to a village known as Leimert Park or Forty-Third and Degnan. (Both, courtesy of Los Angeles Public Library photograph collection.)

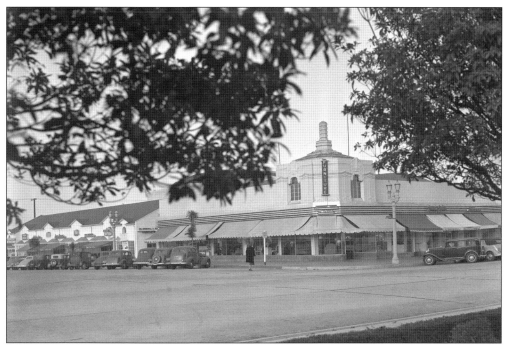

Forty-Third Place and Degnan Boulevard was a busy place in the 1930s. The side view of the Leimert Park Business Center shows cars parked in front of businesses. A glimpse of a local furniture store and studio, automobiles parked along the street, and a sign that reads "Leimert Park Bootery" all add to the charm of this quaint town. The dental office of Dr. Wendell is visible. Below is another view of the shops adjacent to the Leimert Theatre, which is featuring Shirley Temple in *The Little Princess* and John Barrymore in *The Great Man Votes*. (Both, courtesy of Leimert Investment Company.)

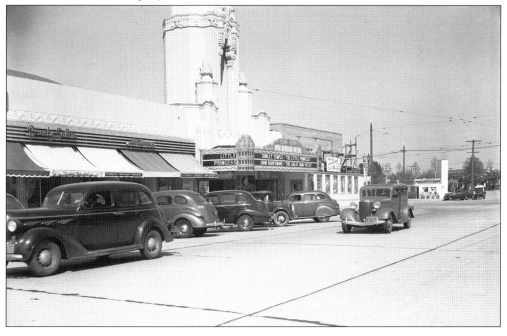

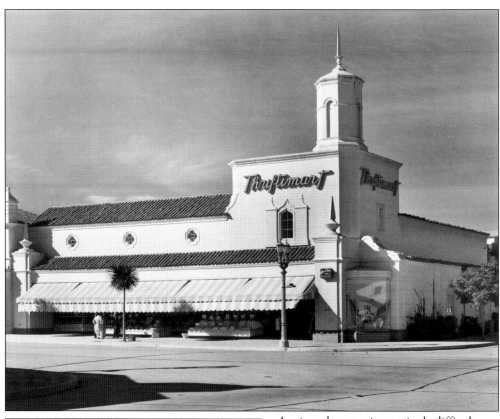

Shop with Confidence
at

J. J. NEWBERRY CO.

5c, 10c and 25c STORE

4311 DEGNAN BLVD.

As times became increasingly difficult for small tenants, larger stores opened in Leimert Park, further adding to the notion that it would become a shopping center and would see high traffic though its major thoroughfares. By the 1930s, Angeles Mesa Drive, Vernon Avenue, and Crenshaw and Leimert Boulevards, among others, were developed and invited merchants of all sorts. In this image, the popular Thriftymart is now located on Forty-Third Place and Degnan Boulevard. Also located on Degnan Boulevard is the J.J. Newberry and Company store, which most referred to as "Newberry's" or the "nickel and dime store." (Both, courtesy of Leimert Investment Company.)

Five

OLYMPIC VILLAGE AND COMMODITIES OF A COMMUNITY

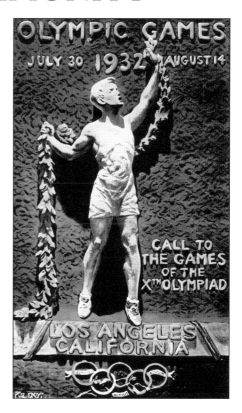

The development of Leimert Park was now complete. The arrival of the Olympic Games would bring even more prominence to Los Angeles, especially in Leimert Park. The self-sufficient and beautifully planned community with all its commodities would be on showcase for the world to see. Pictured is the official poster of the 1932 Olympic Games, created by designer Julio Kilenyi. (Courtesy of private collection.)

William May Garland was born in Westport, Maine, in 1866. He moved to California in 1894 and became auditor to the Pacific Cable Railway Company and a principal sales agent to Henry E. Huntington. Garland also became heavily involved in promoting Southern California's real estate and population boom. (Courtesy of Los Angeles Public Library Photo Collection.)

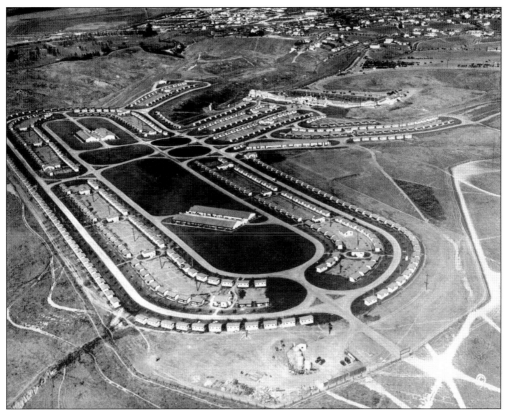

Situated within a mile of Leimert Park, the first Olympic village for the modern Olympic Games was built atop Baldwin Hills. The village (pictured above) housed only the male athletes and their trainers, coaches, and personal attendants, while the female athletes stayed in a luxury hotel downtown. The village consisted of several hundred buildings, including post and telegraph offices, an amphitheater, a hospital, a fire department, and a bank. Despite a worldwide economic depression and predictions that the 1932 Summer Olympics were doomed to fail, 37 countries sent over 1,300 athletes to Southern California, and the games were a huge success. Below is the entrance of the Olympic Village administration building, created in the style of Pueblo Indian architecture. Flags of all the participating Olympic countries are displayed outside of the building. (Both, courtesy of private collection.)

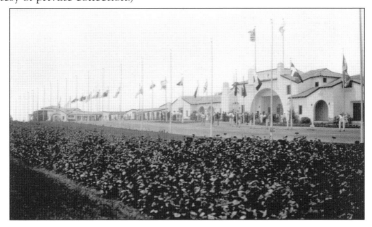

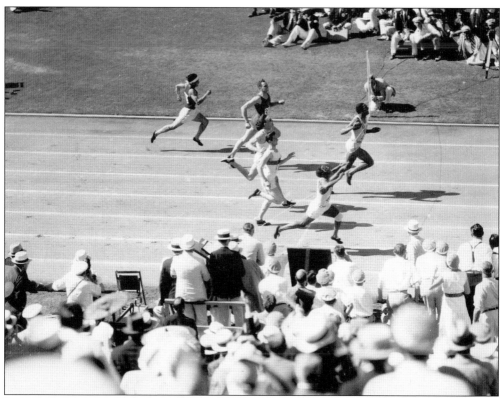

Runners Ralph Metcalfe (pictured below at left) and Thomas "Eddie" Tolan (below at right) were the pride of the US track team at the 1932 Summer Olympics. After much confusion about the results of the 100-meter dash, judges were able to note that Tolan's torso had crossed the finish line just milliseconds before Metcalfe's (above). Tolan became the first African American to receive the title "world's fastest human." (Both, courtesy of private collection.)

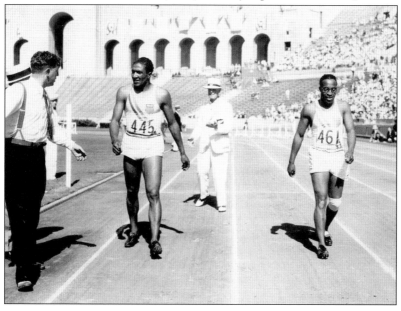

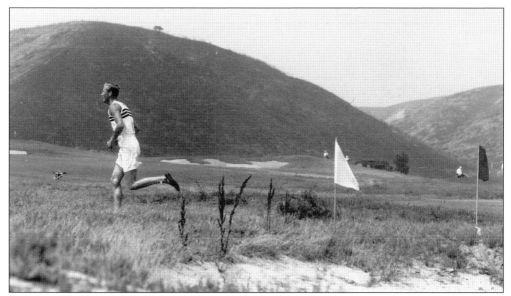

The Sunset Fields Golf Course in Leimert Park was also the location of another official Olympic venue, the running portion of the modern pentathlon. Here, Charles P.D. Legard, from Great Britain's Olympic team, runs across the golf course. Legard won the running portion of the 1932 modern pentathlon but came in eighth place overall. The close proximity of the Olympic games to the neighboring community of Leimert Park brought much attention to the development. (Courtesy of private collection.)

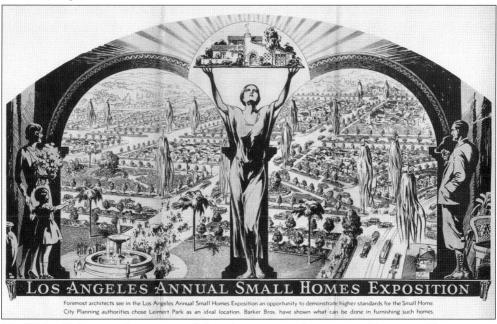

The Walter H. Leimert Company used this advertisement depicting an Olympic goddess raising a fully completed home—a window of opportunity open to families and investors as they looked into this self-sufficient and beautifully planned community. The city planning authorities chose Leimert Park as the ideal location of higher standards for the small home. This event was known as the Los Angeles Annual Small Homes Exposition. (Courtesy of Leimert Investment Company.)

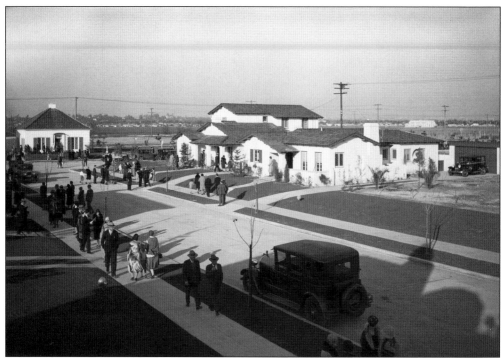

Photographed above in 1930, Leimert Park homes are freshly completed and available for sale. The construction of several homes took place in time for the Olympic games and was publicized in local newspapers. Leimert Park homes on display were fully furnished by Barker Brothers and were exhibited in open house events. As crowds travel to Los Angeles for the Olympic games, the Walter H. Leimert Company staged many of these open houses as a way of marketing. Barker Brothers held seminars for those interested in the interior design of the beautifully decorated Leimert Park homes throughout Los Angeles. Below, other models available within Leimert Park are displayed to potential investors and their families touring the homes and the apartments. Children also accompany their parents to this show. (Both, courtesy of USC Special Collections, Doheny Memorial Library.)

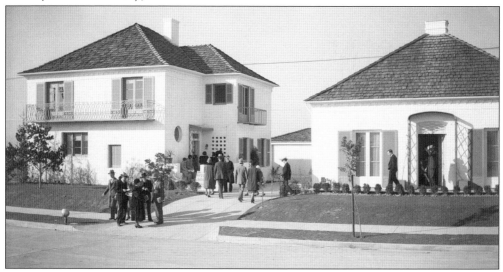

Henry E. Huntington (1850–1927) is remembered for his collection of rare books and arts that led to his legacy, the Huntington Library. He was also one of the most influential figures to Southern California's transit system. Huntington focused his attention on connecting, consolidating, and extending the existing lines, thus creating one of the most intricate interurban systems to exist. (Courtesy the Huntington Library, San Marino, California.)

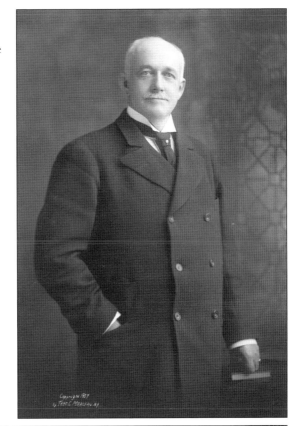

Tracks were lowered on Santa Barbara Avenue in 1927. The trolley is operative as men use shovels on both sides of the road and pedestrians walk along the trail near the trees. The street was soon to be paved, making transportation much more accessible either by automobile or the alternative and convenient railway. (Courtesy of USC Special Collections, Doheny Memorial Library.)

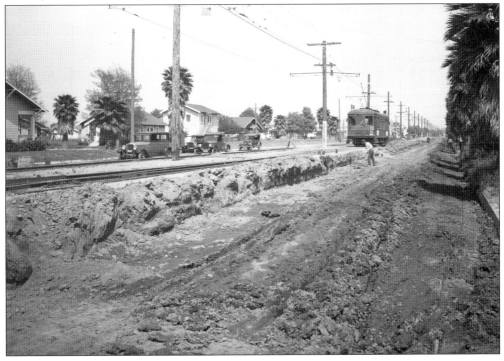

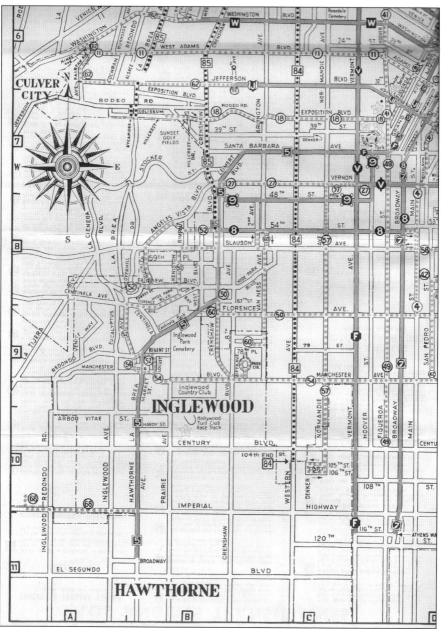

This map shows various transit lines that operated through Hawthorne, Inglewood, Culver City, Leimert Park, and neighboring suburbs from the 1920s to the 1940s. Leimert Park was serviced by the high-speed, 7¢ No. 5 and No. 9 trolley cars and highly advertised this very convenient means of transportation. Known as the Los Angeles Railway, this system of streetcars began to operate in 1901 after being purchased by Philadelphia-born Henry E. Huntington. Transportation had always been at the forefront of all of Walter H. Leimert's developments. In City Terrace, Line B had been created to provide downtown Los Angeles commuters ease of transportation into newly developed communities. The same concept applied in Leimert Park, as easy access to main centers such as the magic circle was made possible by way of the streetcar or railway. (Courtesy of Archives-Los Angeles County Metropolitan Transportation Authority.)

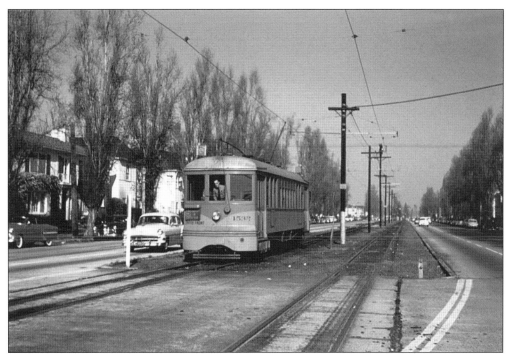

The 1950s photograph above shows the trolley that made commutes efficient via Line No. 5. Leimert Park's thoroughfare extended through Santa Barbara Boulevard and Leimert Boulevard, continuing to Crenshaw Boulevard. Below is the same line being operating along Leimert Boulevard. These forms of transportation were highly used by many of the African American performers of the Central Avenue scene during the 1940s and 1950s. As the music scene moved toward Western Avenue and into the immediate Leimert Park environs, the streetcar was the way to commute to major intersections for those who opted for or relied on the convenience of public transportation. (Both photographs by Alan Weeks, courtesy of Archives-Los Angeles County Metropolitan Transportation Authority.)

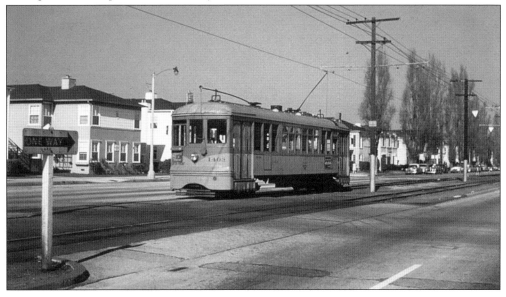

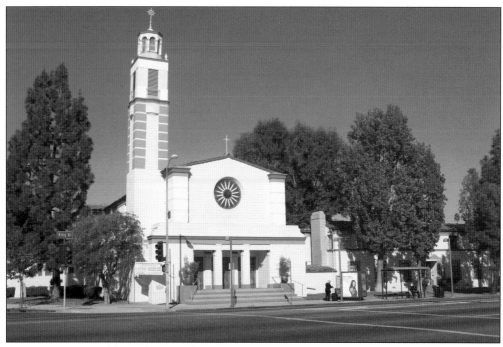

A community could not be complete without religious institutions. Los Angeles, being a predominantly Christian community, had many churches originally part of missions. Leimert Park's Transfiguration Church is located at 2515 West Martin Luther King Jr. Boulevard. The church has been a landmark in Leimert Park for over 70 years and offers a parish and an elementary school of the Catholic faith. (Courtesy of the Exum collection.)

St. Bernadette Parish was officially established by his Excellency John Joseph Cantwell, Archbishop of Los Angeles, on April 28, 1947. Shortly after World War II, the Sunset Fields Golf Course closed and the land was subdivided. The Archdiocese of Los Angeles purchased three and a half acres of property and adjoined it to the St. Bernadette Catholic Church. The clubhouse served as the rectory, office, and dining hall. The church is located at 3825 Don Felipe Drive, and the adobe remains at 3725 Don Felipe Drive. (Courtesy of Los Angeles Public Library photograph collection.)

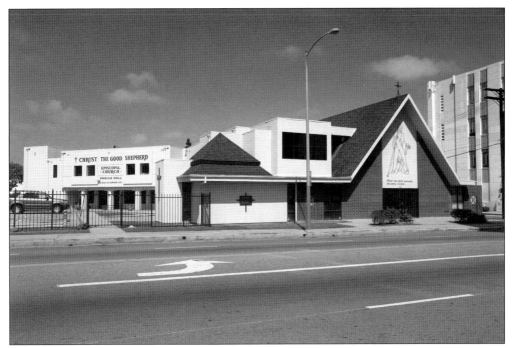

Churches and schools are important components of the character of Leimert Park. Pictured at right is the Episcopal Church of Christ the Good Shepherd, which is located at 3303 West Vernon Avenue. Many people come from neighboring communities to celebrate important events in these churches, which represent religion and culture. (Courtesy of Los Angeles Public Library photograph collection.)

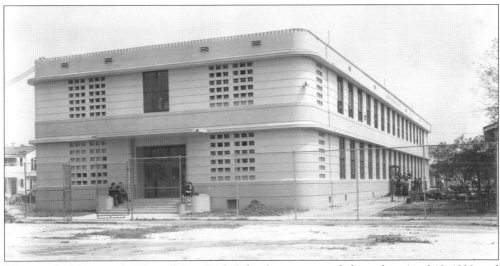

This new building on the Manual Arts High School campus was dedicated on April 18, 1939, and named in honor of Dr. Albert Edgar Wilson, the first principal of the school from 1910 to 1938. Albert E. Wilson Hall was designed by architects Parkinson and Parkinson in the Streamline Moderne style in the Public Works Administration (PWA) mode. The other buildings on campus were constructed in the 1930s. (Courtesy of Los Angeles Public Library photograph collection.)

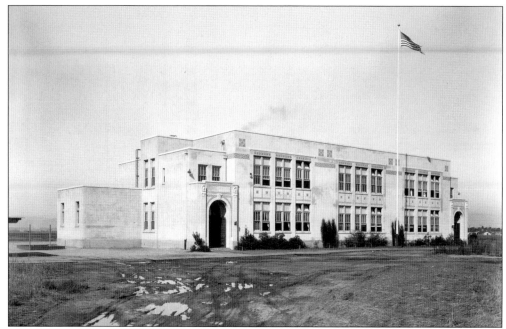

Photographed is Thirty-ninth Street School, which was built in 1926. It was originally named Thirty-eighth Street School and had a student population of 314. In 1999, the school was renamed Tom Bradley Environmental Science and Humanities Charter Magnet to honor the late mayor of Los Angeles. The school is located at 3875 Dublin Avenue. (Courtesy of USC Special Collections, Doheny Memorial Library.)

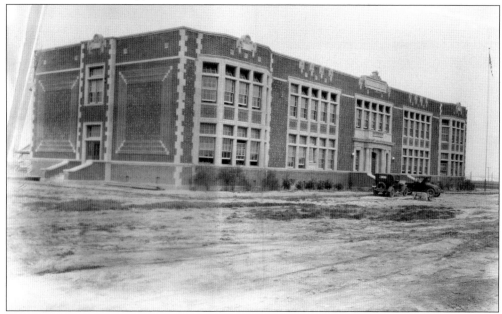

Audubon Junior High School opened in September 1926 and had an original enrollment of 500 pupils. By September 1928, the school consisted of a junior high and high school. Another important school was Forty-second Street Elementary School, featured in all of the advertisements relating to schools in Leimert Park. (Courtesy of USC Special Collections, Doheny Memorial Library.)

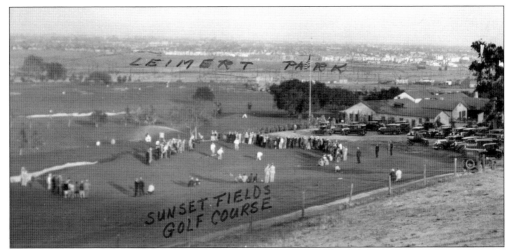

Sunset Fields Golf Course was on land owned by the Baldwin heirs. The Sunset Golf Association leased the land from the Baldwin heirs and used it as the Sunset Fields Clubhouse; the original adobe was also used. These 1928 photographs reflect the close proximity of the Sunset Fields Golf Course to Leimert Park and the remodeled adobe. Sunset Fields Golf Course was located at 3701 West Stocker Street, within walking distance of Mesa Drive from the first tee and clubhouse. Sunset Fields was comprised of three courses, two with 18 holes and a nine-hole, par-three course. Course No. One, with 18 holes, measured 6,637 yards with a par of 72; Course No. Two, with 18 holes, was 6,296 yards and par 72; and Mashie Pitch Course had nine holes, was 1,500 yards, and had a par of 54. A "pay as you play" approach made these public but privately owned courses attractive to the avid golfer. Sunset Fields also featured a restaurant and bar specializing in fine Southern cooking by Aunt Margie, a golf shop, and a locker room. (Above, courtesy of Leimert Investment Company; below, courtesy of Los Angeles Public Library photograph collection.)

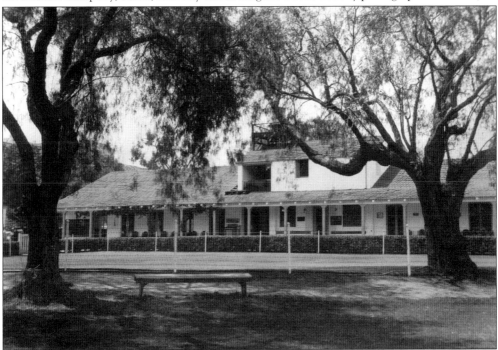

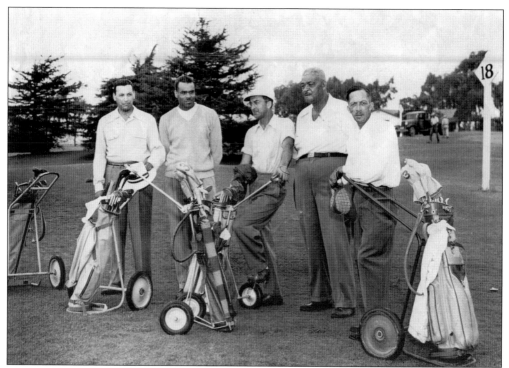

Al Maddox (second from left) and Dr. ? Wallace (fourth from left) are photographed around 1940 with unidentified golfers near the 18th hole at the Sunset Fields Golf Course. The clubhouse is seen at a distance to the left of the trees. (Courtesy of the Halvord Thomas Miller Jr. collection.)

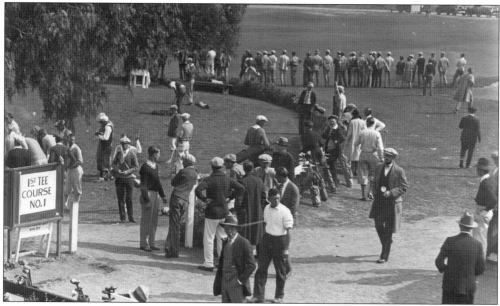

On October 30, 1928, golfers and observers gathered to witness the opening 18 holes on the first day of the Southern California Open Golf Crown for the Willie Hunter title. Fay Coleman's crowd gathers to the left. Elmer Vice is toward the right. (Courtesy of Los Angeles Public Library photograph collection.)

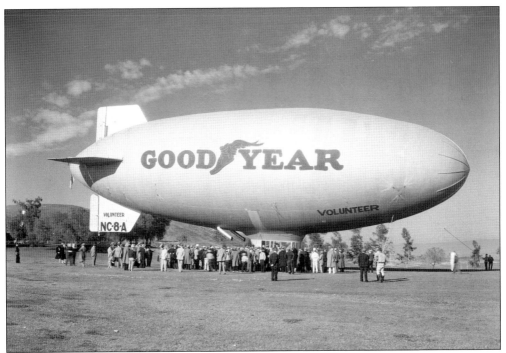

The Sunset Fields Golf Course was also used as a landing site for the Goodyear Blimp in 1930. The Goodyear Rubber and Tire Company named the series of blimps after America's Cup yacht race winners. The Goodyear blimp *Volunteer* was named after the 1887 America's Cup winner. In 1932, the *Volunteer* offered Charles Lindbergh a leisurely ride during the Olympics. (Courtesy of USC Special Collections, Doheny Memorial Library.)

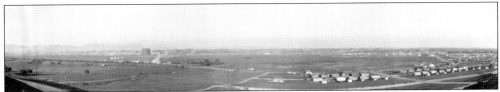

In 1927, the Sunset Fields Golf Course was one of the first amenities of Leimert Park, and it later became a central part of the development. Who could have imagined that this land would become so densely populated in less than 20 years? (Courtesy of the Huntington Library, San Marino, California.)

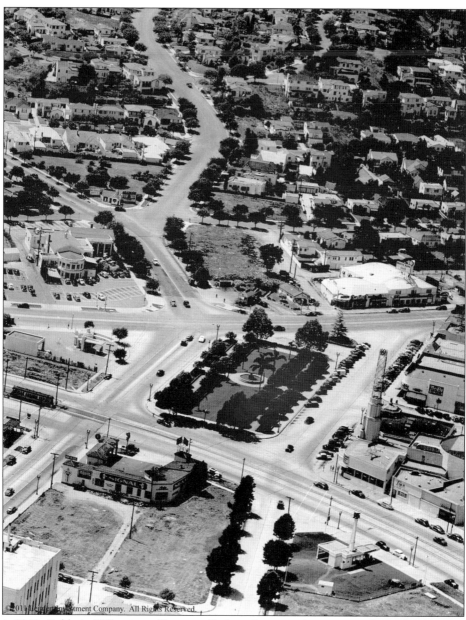

This 1940s Baldwin Hills view of Leimert Park and surrounding areas reflects the fast growth of Los Angeles and the continuously developed metropolitan areas of the city. The Leimert Theatre and its adjoining shopping centers can be seen along with the upward construction of a building. The acquisition of land by Walter H. Leimert and the changes that came after are incredible representations of how a pioneering movement can create long-standing changes and impact the future. Soon after, as Leimert Park continued to grow, other parts of Greater Los Angeles were expanding and contributing to the population boom that has made the city one of the most important financial centers of the world. Leimert Park, with its close proximity to downtown Los Angeles, easy access to freeways and beaches, along with major thoroughfares and widespread use of public transportation, seemed to be the ideal location. (Courtesy of Leimert Investment Company.)

Six

POST–WORLD WAR II
DEVELOPMENT

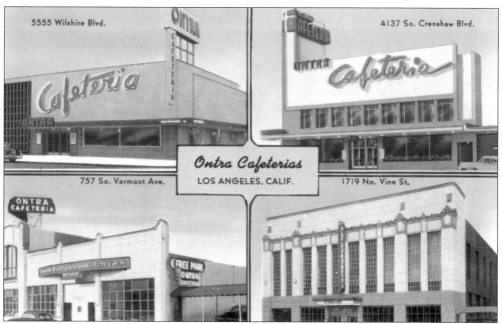

Post World War II brought change in many ways. New business developments rapidly emerged and the lifting of racial covenants marked the beginning of a demographic shift in Leimert Park. This vintage postcard shows new development, the Ontra Cafeteria designed by Albert B. Garner in 1945 located at 4137 Crenshaw Boulevard. During its heyday, the restaurant was a favorite among locals and tourists. (Courtesy of private collection.)

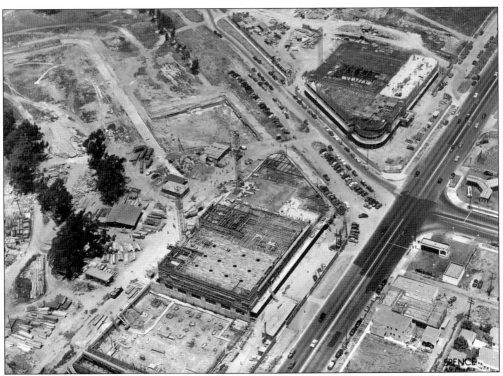

Like many communities around the nation, after World War II, Leimert Park and the immediate environs experienced rapid change and new developments. This 1947 aerial view shows the construction of the Crenshaw Shopping Center, later known as Baldwin Crenshaw Shopping Plaza, and its surrounding areas. What will be the Broadway store, designed by Albert B. Garner in the late Modern suburban style, is pictured to the left. Upon completion, this store will be the largest Broadway department store in the nation, totaling over 210,000 square feet of retail space combined with adjacent retail stores and a Von's Supermarket. Designed with four levels and glass fashion window displays, the Broadway would make its mark as the anchor of one of the very first planned shopping centers in the United States, the Baldwin Hills–Crenshaw Shopping Plaza. Only remnants of the grand greenways, once known as the Sunset Golf Fields, remain. (UCLA Department of Geography, The Benjamin and Gladys Thomas Air Photo Archives.)

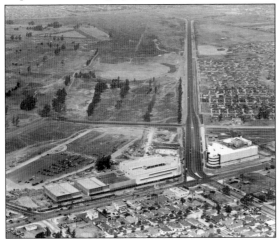

The Crenshaw Shopping Plaza was the first major planned shopping center in the United States. Located across the street from the Broadway is the May Company store designed by architect Albert C. Martin in late Streamline style. The completion of this mall would mark the first time that two competing downtown department stores operated branches in the same suburban development. The May Department Stores Company, purchased in 2005 by Macy's, took on its name. (UCLA Department of Geography, The Benjamin and Gladys Thomas Air Photo Archives.)

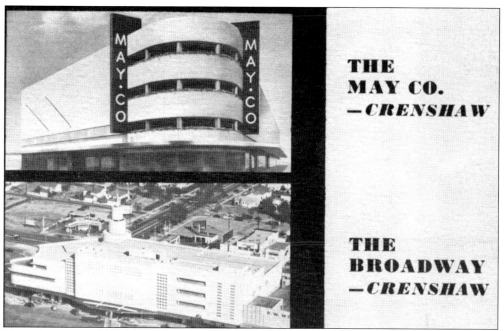

THE
MAY CO.
—CRENSHAW

THE
BROADWAY
—CRENSHAW

This advertisement was distributed to homeowners in and around the Leimert Park area to showcase the newly constructed Broadway and May Company stores. (Courtesy of Leimert Investment Company.)

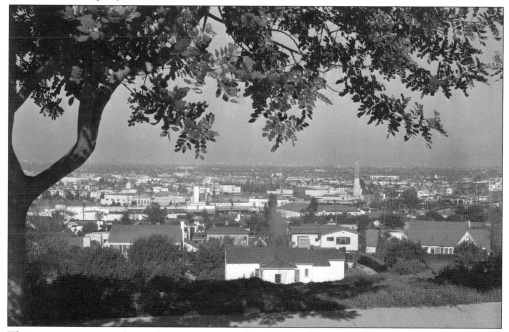

This panoramic view shows the community of Leimert Park as seen from a hilltop street in View Park. By the late 1950s, most of the area's development was complete. Most of the buildings seen down below, such as the Mesa-Vernon Market (right, below the tree line), various storefronts on Crenshaw Boulevard, and the residences in the foreground, are of Spanish-style architecture. (Courtesy of Leimert Investment Company.)

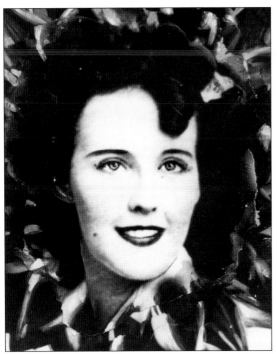

Down the street from the new mall development, a gruesome discovery was made. The body of Elizabeth Short was found on January 15, 1947, in a vacant lot. She was referred to as the "Black Dahlia" because of her dyed black hair and her fondness for dark-colored clothing. To this day, this case remains one of the most notorious murders and unsolved cases in Los Angeles history. (Courtesy of Los Angeles Public Library photograph collection.)

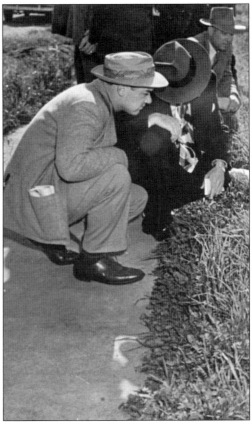

The location of the lot where the "Black Dahlia" was found was near the west side of Norton Avenue between Coliseum Street and Thirtieth Street. In this photograph, investigators can be seen closely examining the mutilated body of Elizabeth Short. (Courtesy of Los Angeles Public Library photograph collection.)

This towering four-level building at 3233 Vernon Avenue was built in 1939. Early on, the structure contained the Axminster Central Offices for the Home Telephone Company. The property was expanded in 1951, then later in 1981. The building has housed the offices of Southern California Telephone and later Pacific Telephone. Today, it serves as a large switching facility for AT&T. (Courtesy of the Exum collection.)

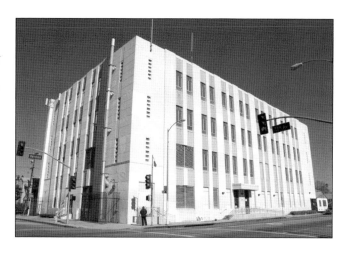

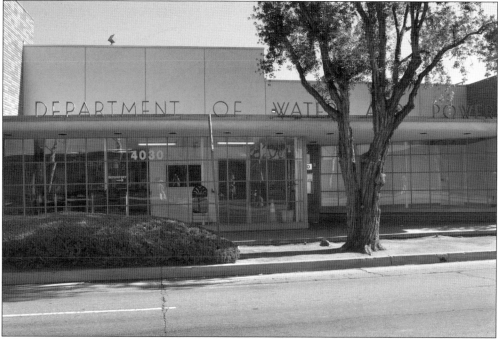

In 1956, the Los Angeles Department of Water and Power (DWP) built a satellite DWP Crenshaw customer service center at 4030 Crenshaw Boulevard. Its facilities included a lobby area with a display and exhibit space, a home economics center, a 225-seat auditorium, a small classroom, offices, and a parking lot, as well as a station. The service center and station reflected the rapid growth of the Crenshaw area; taken together, the facility represented a $1-million investment in the community. (Courtesy of Historical Records Program, Los Angeles Department of Water and Power.)

U.S. COURT DECISION HAILED

THE SIDEWALK

The Supreme Court Decision ... Senator Taylor's Arrest ... Police State ... Political Hope.

By C.A.B.

Government Takes Step

The Government, this week, took a long delayed step. It ruled that Negroes and other minorities can no longer be barred from so-called white neighborhoods.

The Justices ruled, 7 to 0, that "jim crow" real estate agreements cannot be enforced by any court or police power and need not be observed.

PRESS LEADERSHIP

We proudly take our place among the first American newspapers to be published in the interest of Democracy and Equal Justice for all.

California Eagle
A PROGRESSIVE NEWSPAPER FOR PROGRESSIVE GOAL

Vol. 69—No. 5 Los Angeles, California, Thursday, May 6, 1948 44 AD. 9707

Ten Cents

SIXTY-NINE YEARS

Dedicated to the service of the people, great or small, known and unknown, rich or poor, the California EAGLE enters this week, upon its 70th year of continuous publication.

POLICE BEAT UNIDENTIFIED MAN; SENATOR JAILED IN ALABAMA

Race Covenants Ban By High Court Wins Wide Approval Here

The Supreme Court decision barring persons from their voiding restrictive covenants own homes on the basis of race this week was being hailed as color, and it is highly gratifying to have the highest court.

(Continued on Page 8)

CHARGE COPS BEAT MAN IN DAYLIGHT

An almost unbelievable story of police brutality was called to the attention of The California Eagle this week.

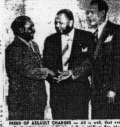

FREED OF ASSAULT CHARGES — All is well, that ends well. So the picture indicates. Left, is William Ray MacKey...

Southerners Jail Senator for Passing Thru 'Wrong Gate'

When Senator Glen Taylor, at learning of the incident, attempted to go into a church...

National Maritime Union

Wife Says Hubby Is Cruel; She's Seeking Divorce

They were married Sept. 22, 1934, Marjorie L. Ewing, that is, and Harris James Ewing. But now their ways have parted.

LOREN MILLER EXPRESSES APPRECIATION IN VICTORY OVER RESTRICTIVE COVENANTS

Loren Miller, who together with Thurgood Marshall, argued the Michigan race restriction case in the United States Supreme Court today issued the following statement in regard to the Court's decision holding that court enforcement of such agreements violates the equal protection clause of the Fourteenth Amendment:

"The victory that we have won in a triumph not only for

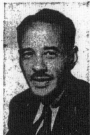

Negroes and members of other minority groups but for all Americans. The right vindicated by the Court is the historic right of an American citizen, of whatever race or color, to purchase and to occupy, a home where he wills. Such a right makes democracy more secure and every American is freer today than he was yesterday by force of the decision.

NAACP Reaffirms Non-Partisanship

NEW YORK — Clarifying and reaffirming the non-partisan position of the National Association for the Advancement of Colored People, a committee of the organization's national board of directors this week adopted the following resolution:

"It is the policy of the NAACP

Museum To Display Rare Diamond

A rare mineralogical specimen of a diamond in the rough partially enclosed in the original rock matrix in which it was found, has been acquired by the Los Angeles County Museum in Exposition Park, according to James H. Breasted, Jr., director.

On May 3, 1948, in *Shelley v. Kraemer*, the United States Supreme Court rendered a decision to lift restrictive covenants. As a result, developers could not use racial covenants in their deeds. Throughout the United States, these covenants were lifted and doors opened for ethnic groups to move into more desirable residential communities, including Leimert Park. The *California Eagle* newspaper, dated May 6, 1948, headlined the landmark ruling. (Courtesy of Southern California Research Library.)

This 1948 news article from the *California Eagle* shows Loren Miller, the attorney who, along with Thorgood Marshall, successfully argued the landmark case before the US Supreme Court. In this article, Miller comments on his victory. (Courtesy of Southern California Library for Social Research.)

Ruth Spencer, photographed here in front of her home, shared the difficulties of owning property even after the covenants were lifted. Through a white intermediary, Ruth and her late husband, Leonard Spencer, purchased a vacant lot once used as a World War II Victory Garden. The Spencers spent two years making eight changes to their building plans in order for the Leimert Park Community Association to approve their design. They were able to build their home in 1953. (Courtesy of the Exum collection.)

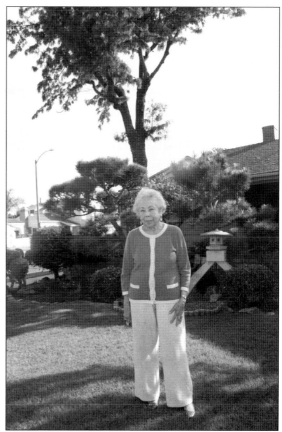

After the 1948 Supreme Court ruling that banned segregationist covenants on properties, many of Leimert Park's earlier residents migrated to the suburbs, creating housing opportunities for ethnic groups. Kazuo K. Inouye, owner of this realty company located at 3112 Jefferson Boulevard, assisted Japanese Americans as well as African Americans in pursuing housing opportunities in the Leimert Park and Crenshaw District areas. (Courtesy of the Exum collection.)

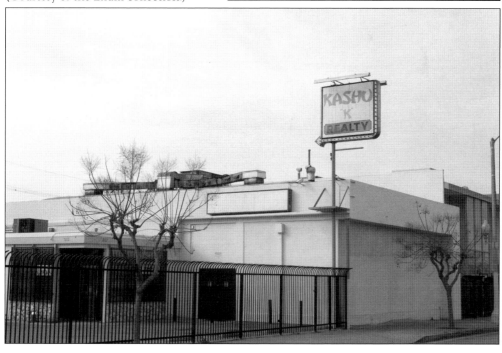

After War World II, Japanese Americans began to migrate westward to establish businesses and purchase homes following the lifting of the restrictive covenants. Many Japanese Americans settled in large numbers in and around Leimert Park and the Crenshaw District area. With this migration and settlement came the development of Japanese businesses such as the Crenshaw Square Shopping Center. Located along the Crenshaw corridor at 3840 Crenshaw Boulevard, the building was designed by noted Japanese architect Dike Nagamo. Comprised mostly of offices and small retail shops, this structure was the main shopping center for Japanese American residents of Leimert Park and the surrounding Crenshaw District areas. (Courtesy of Brian Minami Pictures.)

In 1958, Holiday Bowl was founded by five Japanese Americans, and it was a significant part of the rebuilding process of the Nisei community after internment during World War II. The building consisted of a combination bowling alley, pool hall, bar, and coffee shop. Attracting a diverse clientele, the coffee shop served a cross section of ethnic cuisine, including Japanese udon, Chinese chow mein, and Southern grits, short ribs, and biscuits and gravy. The building included Googie-styled architecture designed by Helen Liu Fong of the Armet & Davis architectural firm. (Courtesy of Brian Minami Pictures.)

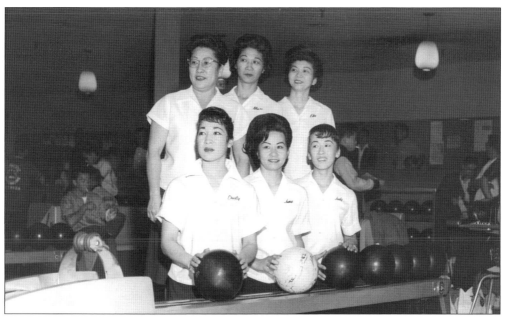

This November 19, 1962, image shows the champion women's bowling team at the Holiday Bowl in the Crenshaw District. The portrait includes six female bowlers in white shirts with their names (including Mari, Eiko, Dusty, June, Judy, and Chiyo) on the left sides of the shirts. (Courtesy of Japanese American National Museum Collection, Hirasaki National Resource Center.)

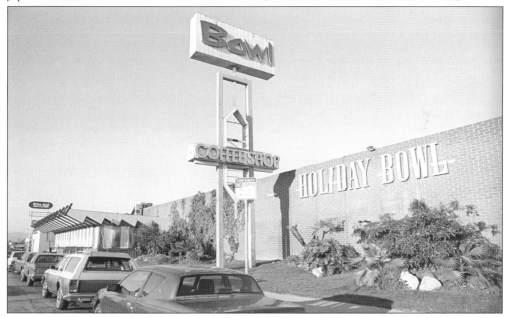

This image shows the exterior view of the Holiday Bowl with the Googie-style sign reading "Bowl." In 2000, the bowl closed and was set for demolition. Despite great disapproval and efforts to preserve the building as a cultural landmark, it was torn down in 2003. The bowling alley was demolished and replaced with a mini mall. The Holiday Bowl bar and coffee shop was purchased by Starbucks Coffee, which kept its exterior structure. The famous "Bowl" sign is now on exhibit at the Neon Museum in Pasadena. (Courtesy of Brian Minami Pictures.)

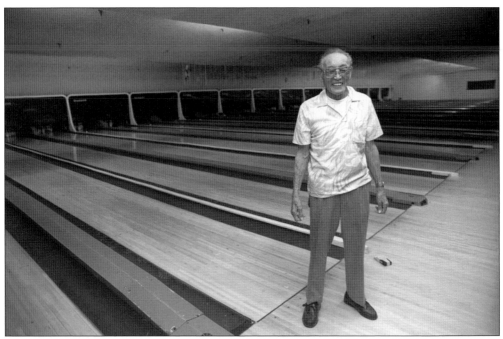

On the Holiday Bowl's last day of operation, Sunday, May 7, 2000, a Japanese American bowler known to locals as "Juggie" revisits the lane in which he bowled a perfect 300 game. (Courtesy of Brian Minami Pictures.)

On March 23, 1996, Mary Shizuro and Fojio Hori, having given up ownership of the Holiday Bowl, opened Tak's Coffeehouse at 3870 Crenshaw Boulevard inside the Crenshaw Shopping Square mini-mall plaza. Many of the Holiday Bowl's clientele became Tak's customers. (Courtesy of the Bravo family collection.)

Tak's Coffeehouse has become a favorite early-morning breakfast eatery for locals and visitors alike. This photograph was taken on the opening day of Tak's Café on March 23, 1996. Patrons are seen enjoying breakfast and camaraderie. (Courtesy of the Bravo family collection.)

Sometimes referred to by customers as "Little Holiday Bowl," the coffeehouse continues to serve a diverse ethnic clientele. Pictured from left to right are Shirley Azusa, waitress; Angie Bravo; waitress; Mary Shizuro, co-owner; Fojio Hori, co-owner; and Chino Bravo, cook. (Courtesy of the Bravo family collection.)

Shown here are the new owners of Tak's Coffeeshop, husband and wife Chino and Angie Bravo. Angie started as a waitress and Chino Bravo began as a cook at the original Holiday Bowl. (Courtesy of the Bravo family.)

Japanese Americans purchased homes in Leimert Park and the adjoining Crenshaw District area, with most of the houses located along Norton and Bronson Avenues. Homes were built with Japanese architectural designs and landscaping. Pictured here is a home on Norton Avenue in Leimert Park. (Courtesy of the Exum collection.)

These homes along Bronson Avenue show the influence of Japanese architecture and landscaping. The Crenshaw Square Shopping Center is located across the street from these homes. (Courtesy of the Exum collection.)

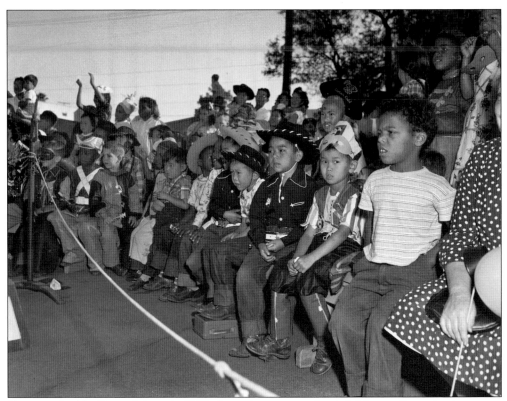

Photographed by Harry Adams in 1958, these elementary school children reflect what is now an expanding multicultural community adjoining Leimert Park. (Courtesy of the Institute for Arts and Media, California State University, Northridge.)

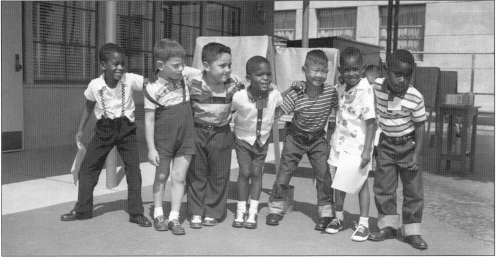

Charles Williams photographed these children celebrating Halloween at the Sixth Avenue School. With the conclusion of World War II and racial covenants lifted, Leimert Park and its surrounding areas shift toward a multicultural community. Japanese, African Americans, as well as other minorities influence art, culture, and business in and around Leimert Park. (Courtesy of the Institute for Arts and Media, California State University Northridge.)

Seven

BIRTH OF A VILLAGE

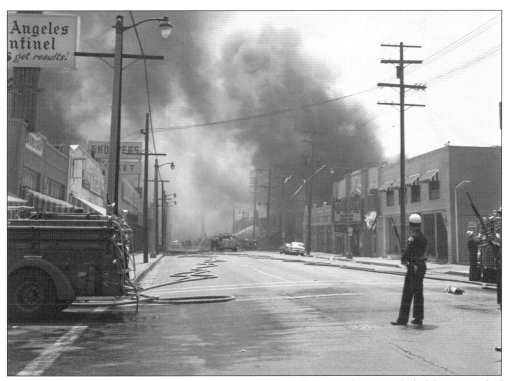

In the summer of 1965, simmering racial tensions among Los Angelenos exploded for a period of five days. As depicted in this Harry Adams photograph, businesses were burned and vandalized throughout Los Angeles during the Watts Riots. From the ashes of the riots, rose a new sense of community, pride, and empowerment beginning with the civil rights movement that paved the way for the Black Arts Movement. Artists of all races and ethnicities, musicians, poets, and entertainers made Leimert Park a haven for freedom of expression. (Courtesy of the Institute for Arts and Media, California State University Northridge.)

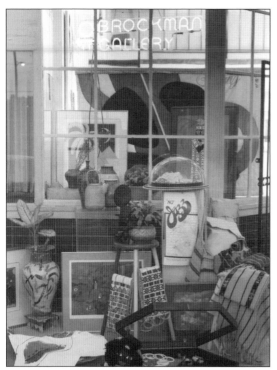

Motivated by their participation in the 1966 "Meredith March" in Jackson, Mississippi, brothers Alonzo and Dale Brockman traveled across the country from the South to Los Angeles to start their careers in California. In 1967, they opened Brockman Gallery, named after their maternal grandmother, at 4334 Degnan Boulevard. The gallery would go on to nurture the early careers of respected artists John Outterbridge and David Hammons. (Courtesy of the Brockman Gallery, archives of Alonzo and Dale Davis.)

As the sole cultural institution in Leimert Park in 1967, Brockman Gallery established the foundation of what is known now as Leimert Park Village. Photographed here are brothers Alonzo Davis (right) and Dale Davis (left) and their father, Alonzo J. Davis (center). (Courtesy of the Brockman Gallery, archives Alonzo and Dale Davis.)

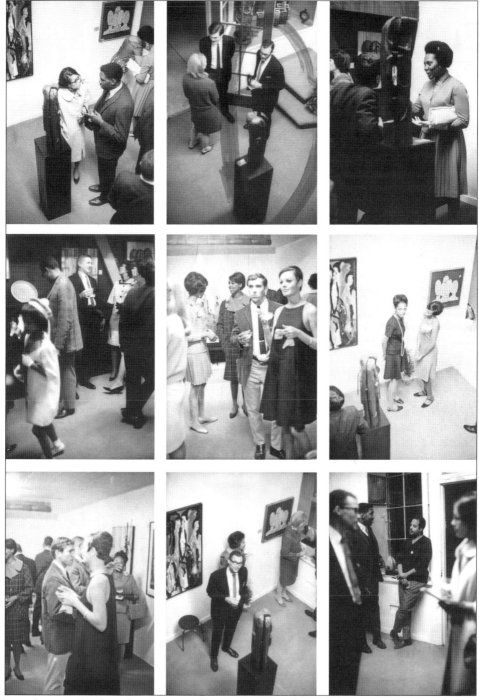

These photographs show Brockman Gallery's opening night and the guests who attended. This opening would mark the beginning of an important era—the birth of Leimert Park as an art and cultural center. As the sole cultural institution is Leimert Park in 1967, this gallery would help establish the foundation at what is known now as Leimert Park Village. (Courtesy of the Brockman Gallery, archives of Alonzo and Dale Davis.)

Brockman Gallery partnered with community organizations to provide gallery experiences outside of their gallery's walls. Cultural events, including music and film festivals, street fairs, and open exhibits in parks and recreation centers were presented. This image shows a Davis brothers–sponsored activity, Art in the Park. The Axminster Building is visible in the background. (Courtesy of the Brockman Gallery, archives of Alonzo and Dale Davis.)

A street musician plays his cello in front of the Leimert Park Village merchant shops while Agnes Moses Davis, the mother of Alonzo and Dale Davis, looks on. (Courtesy of the Brockman Gallery, archives of Alonzo and Dale Davis.)

Samella Lewis is an artist, educator, writer, and filmmaker who in 1976 founded the Museum of African American Art in Los Angeles at 4005 Crenshaw Boulevard in Leimert Park. Lewis was intricately involved in the arts and used her personal knowledge and experiences as a black woman to address issues of race. Lewis also founded the African American Museum of Art in the Crenshaw Macy's department store. (Courtesy of Mercedes Rielly.)

Inspired by the synergy from the Brockman Gallery, Ramsess came to Leimert Park in 1979 to attend workshops at Brockman Gallery. Ramsess specializes in painting, stained glass, mosaic, murals, and political cartoons. He opened his own studio in Leimert Park in 1979 at 4342 Degnan Boulevard but closed down in 2000 due to raising rents. (Courtesy of the Ben Caldwell collection.)

In 1984, Ben Caldwell founded KAOS Network at 4343 Forty-third Place in Leimert Park. The film media center was founded as a meeting place for creative adults and young people to learn and use new media technology. Classes and music programs are offered for the community. Caldwell made his commitment to Leimert Park Village while he was a UCLA film student in the 1970s and while working as a student intern at the Brockman Gallery. (Courtesy of the Ben Caldwell collection.)

Several innovative groups, like the Hollywatts Project, began here. This project included a multimedia performance experience with members Ben Caldwell (center) performing as disc jockey, Roger Guenveur Smith (far right) rapping, and Wesley Michael Groves (far left) on media/camera. The group performed quarterly from 1984 to 1992. Their last performance took place at the La Mama in New York City. (Courtesy of the Ben Caldwell collection.)

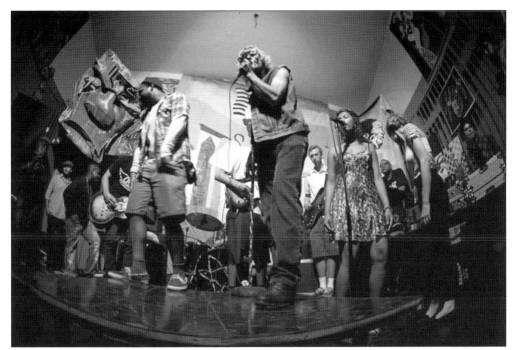

Project Blowed, founded in 1994 by hip-hop artist Aceyalone and friends, is the longest-running hip-hop open mic in the world. Well known for its Thursday night sessions at KAOS Network, the program has helped launched the careers of hip-hop artists Aceyalone, Medusa, Busdriver, Freestyle Fellowship, and Jurassic Five, among others. (Courtesy of the Ben Caldwell collection.)

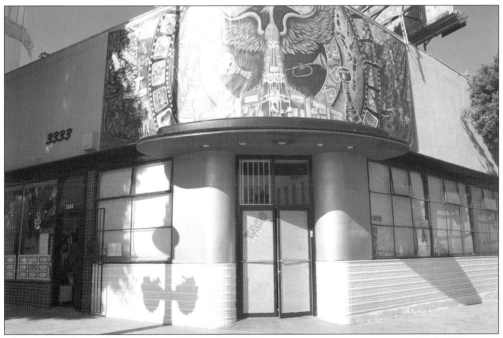

This image shows the exterior of where KAOS Network is located in Leimert Park. (Courtesy of the Exum collection.)

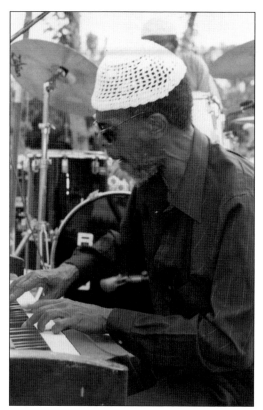

Horace Tapscott (1934–1999) was an American jazz pianist, composer, and trombonist. In 1961, he formed the groundbreaking Pan African People's Arkestra and the vocal ensemble the Voices of UGMAA, which later featured the great Dwight Trible as both its vocal director and soloist. Tapscott was a leading figure in the developing Black Arts movement and was cofounder of the legendary Leimert Park World Stage performance space along with the great jazz drum legend Billy Higgins and poet extraordinaire Kamau, Daa'ood. Horace mentored to hundreds of young, aspiring musicians, becoming a mainstay in the Los Angeles music scene. (Courtesy of Sabir Majeed.)

Shown here are some members of Horace Tapscott's Pan Afrikan People's Arkestra, originally called the Underground Musicians Association. In 1969, a quintet representing the core of the Arkestra recorded on Bob Thiele's Flying Dutchman Records label, resulting in the record *The Giant Has Awakened.* (Courtesy of Sabir Majeed.)

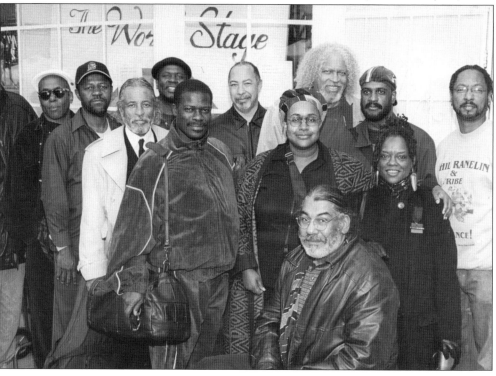

Tony Gieske

The historic and world-renowned World Stage venue was founded by poet and community activist Kamau Daaood (right) and the late jazz drummer Billy Higgins (above) in 1989. The small performance venue has provided a rehearsal space and a nurturing environment that has given birth to at least two young jazz groups, Black/Note and B Sharp Quartet. Performers like Dianne Reeves, Chaka Khan, Ahmad Jamal, Horace Silver, and others have appeared on this historic performance stage. Workshops, jam sessions, and performance series are also available to help provide support, training, and creative outlets for artists and musicians in the area. (Both, courtesy of the Tony Gieske collection.)

Dwight Trible is considered one of America's premier jazz vocalist. He has released four critically acclaimed CDs of late: *Horace*, 2001; *Living Water*, 2004; *Dwight Trible & Life Forces —Love is the Answer*, 2005; and his newest release, *Cosmic*, 2011. He has also released numerous singles. Trible is also an activist and advocate for the arts and has been a salient figure in the development of Leimert Park as an African American cultural mecca. (Courtesy of Matt Gibson.)

The World Stage, located on Degnan Boulevard in Leimert Park Village, gives musicians the opportunity to hone their musical skills before a live audience. Pictured are musicians playing at the historic performance space, including jazz singer Dwight Trible, pictured at left. (Both, courtesy of Matt Gibson.)

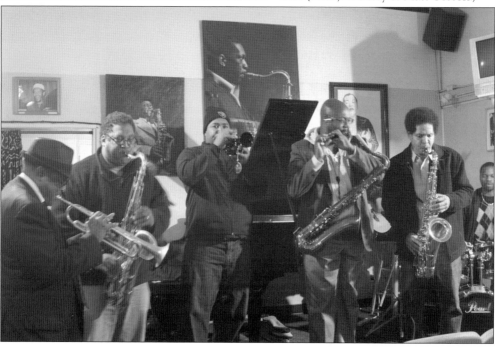

In late 1980s, Brian Breye founded the Museum in Black at 4331 Degnan Boulevard in Leimert Park as a place to display and sell international artifacts, antiques, and black memorabilia. It occasionally functioned as a community living room. The Museum in Black venue officially closed in July 2005 due to increasing rents. (Courtesy of the Sabir Majeed collection.)

Richard Fulton, a formerly homeless man, founded the storefront coffee and jazz house Fifth Street Dick's Coffeehouse. Fulton, seated, is shown here greeting jazz legend, Gerald Wilson outside his café. Fulton passed away from throat cancer in 1999. (Courtesy of Sabir Majeed.)

Fifth Street Dick's Coffeehouse became a popular gathering spot for residents and visitors alike. This image shows two men seated outside the café playing a game of chess while enjoying the beautiful scenery of Leimert Park. After Fulton's passing, the neighborhood café remained closed until 2005, when Fulton's longtime companion, Erma Kent, reopened the coffeehouse at a different location on Degnan Boulevard. The coffeehouse closed its doors for the last time three years ago—under different ownership and management—in 2010. (Courtesy of Ben Caldwell.)

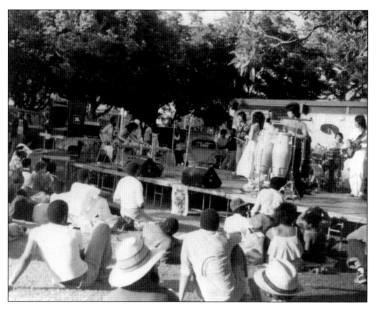

In 1930, the Leimert family gave Leimert Park Square to the City of Los Angeles as a gift to the community to use as a public and open space. Leimert Park Square is host to many special events and activities throughout the year. This c. 1970 image shows a captive audience listening to the musical group Hiroshima. (Courtesy of Brockman Gallery, archives of Alonzo and Dale Davis.)

In 1977, the Leimert Theatre was sold to a religious organization that renamed it the Watch Tower. A decade later, neighborhood activist and famed actress Marla Gibbs purchased the landmark theater and renamed it the Vision Theatre. Through her efforts and hard work, the theater was revitalized and Crossroads Art Academy was established at 4310 Degnan Boulevard to provide programs in the arts to aspiring inner-city youth. Programs offered at the academy included acting and performing classes and meet-and-greet opportunities for youth to meet directors, casting executives, and working actors. However, after the 1992 riots, coupled with an economic recession, the area was badly impacted. In 1997, the property was foreclosed and the City of Los Angeles assumed ownership. (Courtesy of Mayme A. Clayton Library and Museum.)

Afrocentric vases on the streets of Leimert Park can be seen and appreciated by visitors. Leimert Park was chosen as one of the participating neighborhoods for the Los Angeles Neighborhood Initiative (LANI) program. This program sponsors improvements for initiative items such as a transit information center, bus shelters with matching benches, trash receptacles, and the placement of potted trees and flowers, as seen in this photograph. (Courtesy of the Exum collection.)

Pictured are two street banners from the Leimert Park History Banner project. This project, which consists of 86 images of American leaders, artists, and activists—from Sojourner Truth and Martin Luther King Jr. to Bessie Smith and Michael Jackson—is installed on light poles around the neighborhood. Created by the Leimert Park Merchant's Association, the banners were designed by Oakland artist Doniphan Blair. (Courtesy of Exum collection.)

Eight

Tour of Historical and Cultural Landmarks

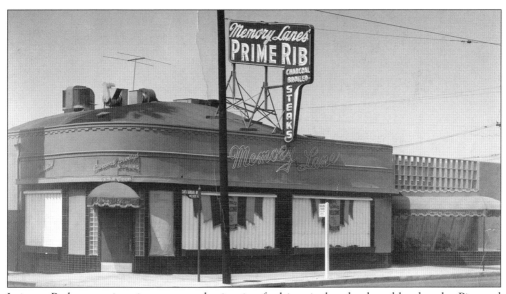

Leimert Park comes into its own as a destination for historical and cultural landmarks. Pictured is the famous Memory Lane Prime Rib Superclub, which first opened its doors in 1959. Originally owned and operated by Lawrence Hearn, the nightspot hosted some of the great talents of the day, including entertainers Ester Phillips, Sam Fletcher, Willie Bobo, Red Foxx, Flappy White, Sir Lady Java, and Nat King Cole. (Courtesy of Oliver Hearn.)

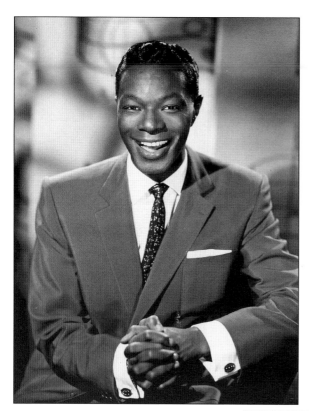

Nat "King" Cole was an American musician, singer, and composer born in Montgomery, Alabama, as Nathaniel Adams Coles. Originally a jazz pianist, Cole played in Los Angeles nightclubs and in 1938 formed the original King Cole Trio. Cole's last performance was here at Memory Lane Supper Club. Shortly after his appearance at the venue, he was hospitalized and later passed away from lung cancer on February 15, 1965. (Courtesy of Mayme A. Clayton Library and Museum.)

The club's lineup was often advertised in the *Los Angeles Scoop* newspaper. Marla Gibbs purchased the supper club in 1980 and renamed it Marla's Memory Lane Jazz supper club. The club remained open until 1999. Other popular clubs in and around Leimert Park and the Crenshaw area included Freddie Jetts Pied Piper, Parison Room, Total Experience, Page Four, and the Flying Fox. Sir Lady Java, pictured here, was one of the many entertainers who appeared at the popular nightspot. (Courtesy of the Institute for Arts and Media, California State University Northridge.)

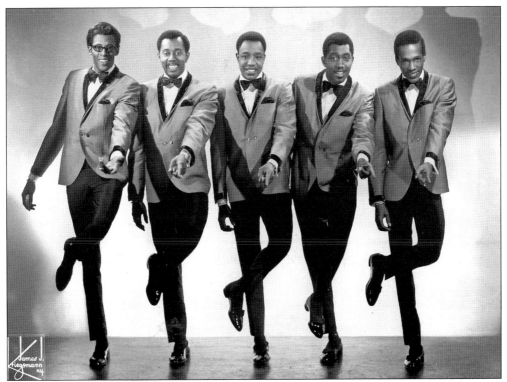

In 1966, John Daniels opened Maverick's Flat Nightclub and Restaurant. It soon became one of LA's premier jazz, soul, and rhythm-and-blues venues and a cultural institution in Los Angeles. Dubbed the "Apollo of the West," Maverick's Flat featured talents such as Marvin Gaye, Parliament Funkadelic, and Ike and Tina Turner. The Temptations (pictured above) performed as the club's opening act on February 28, 1966, and used the interior of the club as inspiration for the cover of their 1970 album, *Psychedelic Shack*. The Los Angeles Cultural Heritage Commission recognized Maverick's Flat as a historical cultural monument for the role it played in pioneering the city's black music scene. (Above, courtesy of Mayme A. Clayton Library and Museum; below, courtesy of Exum collection.)

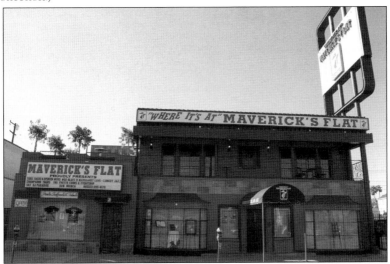

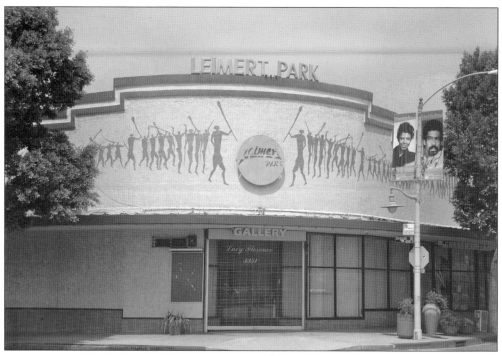

The venue at 3351 West Forty-third has hosted some of Leimert Park's finest art galleries and performance spaces. During the early 1990s ,Earl Underwood owned and operated the Leimert Park Fine Arts Gallery. Continuing the tradition, twin brothers Ron and Richard Harris opened the Lucy Florence Coffeehouse and Cultural Center. Today, the venue is the location for the Fernando Pullum Community Arts and Performance Center. (Courtesy of Sabir Majeed.)

In 1977, Fred A. Calloway opened the Regency West supper club as a premier locale for hosting special events and social gatherings in Leimert Park. The venue, located at 3339 West Forty-third Street, is also known as the spot where late comedian Robin Harris got his start. Other headliners who have appeared at the venue include Eddie Murphy, Martin Lawrence, Joe and Guy Torry, Chris Tucker, the Wayans brothers, Bernie Mac, and Dave Chapelle, among others. The venue has also hosted concerts featuring Lisa Deveaux, Cal Bennet, and others, as well as a Whoopi Goldberg HBO special. (Courtesy of the Exum collection.)

With its tree-lined streets and two-story homes built mostly in the 1940s, this is one of the famous streets in Leimert Park. Named after American film and television actress Katharine Hepburn, this street contains the former homes of notable entertainers, including Ray Charles and Ella Fitzgerald. The 1957 television series *Blondie and Dagwood*, starring Penny Singleton, was filmed at one of the Hepburn homes, and Ray Charles is rumored to have ridden his motorcycle on this street. (Courtesy of Malcolm Ali.)

Robert C. Farrell served 17 years as councilman of the Eighth District, which covers the boundaries of Leimert Park and the Crenshaw district. During his term in office, he introduced a proposal to city council to rename the seven-mile stretch of Santa Barbara Avenue "Martin Luther King Jr. Boulevard." City of Los Angeles Ordinance No. 157091, naming the street after the slain civil rights leader and Nobel Peace Prize winner, became effective on September 8, 1982. (Courtesy of Sabir Majeed.)

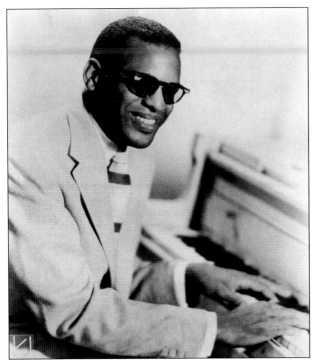

Legendary musician Ray Charles lived in Leimert Park in the late 1960s. His recording studio, Recording Production and Management (RPM), was located at 2017 Washington Boulevard, within very close proximity to his home. (Courtesy of Mayme A. Clayton Library and Museum.)

Photographed here is the two-story home that Ray Charles and his family resided in while living in Leimert Park during the late 1960s. Located at 3910 Hepburn Avenue, this house consists of four bedrooms and three bathrooms and more than 2,644 square feet of living space. The house was built in 1945 and designed by noted architect Hiram J. Hamer. Director Taylor Hackford also featured the home in the 2005 film *Ray*, starring Jamie Foxx. (Courtesy of the Exum collection.)

Ella Fitzgerald, dubbed "The First Lady of Song," was the most popular female jazz singer in the United States for more than half a century. In her lifetime, she won 13 Grammy awards and sold more than 40 million albums. With an ageless and silky voice, Fitzgerald sang sultry ballads and jazz with some of jazz's best, from Duke Ellington, Count Basie, and Nat King Cole to Frank Sinatra, Dizzy Gillespie, and Benny Goodman. (Courtesy of Mayme A. Clayton Library and Museum)

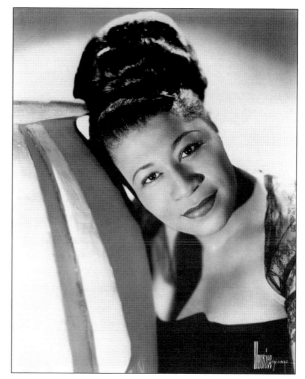

Ella Fitzgerald lived in this two-story, single-family home in the late 1960s. She purchased the home after moving to Los Angeles to recuperate from a surgical procedure. The three-bedroom, three-bathroom home located on Hepburn Avenue in Leimert Park has 2,853 square feet and was built in 1949 by John Shield. (Courtesy of the Exum collection.)

Former Los Angeles mayor Tom Bradley, the first African American elected to the office, resided in this three-bedroom, two-bathroom home at 3807 Welland Avenue. After his retirement, the late mayor returned to this neighborhood, where he purchased another home in View Park. Mayor Bradley's daughter, Phyllis Bradley, maintains his original Leimert Park residence. A sign denoting the mayor's residency can be seen on the front lawn. (Left, courtesy of Mayme A. Clayton Library and Museum; below, courtesy of Exum collection.)

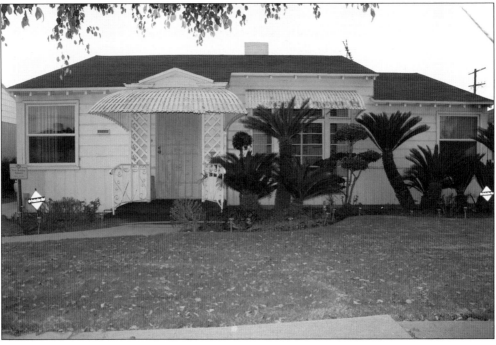

On December 15, 1968, Angelus Funeral Home, pictured below, opened its doors and made history as the only black-owned-and-operated business property on Crenshaw. Located at 3874 on Crenshaw Boulevard, the building was designed by noted African American architect Paul R. Williams (pictured right) in the Spanish Colonial and Georgian Revival Styles with Art Deco elements. The building was also listed as a Los Angeles Historic Cultural Monument in 2006 and is in the 2009 National Register of Historic Places. (Right, courtesy of Mayme Clayton Library and Museum; below, courtesy of Exum collection.)

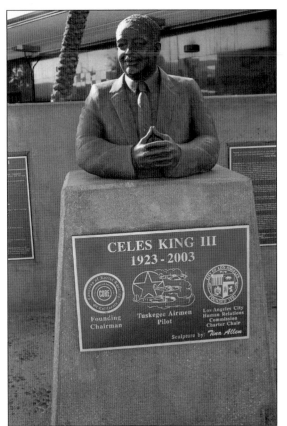

Celest King III, born on September 18, 1923, was a noted community leader, political activist, and bail bondsman. During World War II, he enlisted in the military and became a pilot with the Tuskegee Airmen. After completing his military service, he returned to Los Angeles and founded King Bond Agency in 1951 with his father. This bust of him (designed by Tina Allen), located at the front entrance of the Crenshaw Baldwin Hills Plaza, commemorates his extraordinary contributions to the community. (Courtesy of the Exum collection.)

Taking a walk along Degnan Boulevard, one will see bronze pyramids planted in the ground. They were created in honor of 32 people who have contributed to their community and highlight the honorees' names, artistic fields, and places and years of birth. The honorees include Billy Higgins, Horace Tapscott, Dexter Gordon, Marla Gibbs, Cecil Ferguson, Kamau Daaood, and others. *Sankofa* is an African symbol and principle from the Akan people of Ghana and is a reminder that people must recognize, respect, and learn from the past so that present and future generations can forge a progressive and successful future. (Courtesy of the Exum collection.)

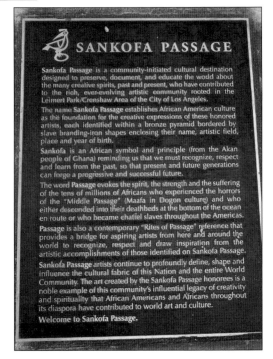

Nine

PEOPLE, PLACES, AND COMMUNITY CELEBRATIONS

In Leimert Park people, places and community celebrations abound year-round. It is a place where people converge for festivals, to mark celebrations and special occasions. Mayor Thomas Bradley is pictured riding from Crenshaw Boulevard to Leimert Park during his campaign for mayor of Los Angeles in 1973. In 1963, Bradley became the city's first African American council member, and in 1973, he defeated incumbent Sam Yorty to become the first African American mayor of Los Angeles and only the second African American mayor of a major US city. (Courtesy of Los Angeles Public Library photograph collection.)

Today, the Martin Luther King Jr. Day Parade is one of the city's largest parades and starts and ends in Leimert Park. The parade begins at the intersection of Western Avenue and Martin Luther King Jr. Boulevard and ends at Crenshaw Boulevard and Vernon Avenue. The festivities culminate with a fair and a gospel concert in Leimert Park Village. The image below shows Councilman Bernard C. Parks riding with his wife, Mrs. Bobbie Parks, during the annual King Day Parade (Both, courtesy of the Exum collection.)

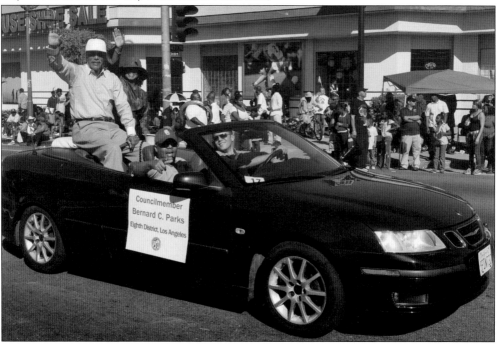

Halvor Thomas Miller, Jr., an attorney and community activist (left) is seen with fellow lawyers Loren Miller, Jr. (right) and Morgan M. Morten, discussing the 1968 Valley State College case in which 28 students were arrested and charged with taking over a campus administration building. Halvor, also the nephew of Loren Miller Sr., has operated his law firm in Leimert Park for over 45 years. (Courtesy of Havlor Thomas Miller Jr.)

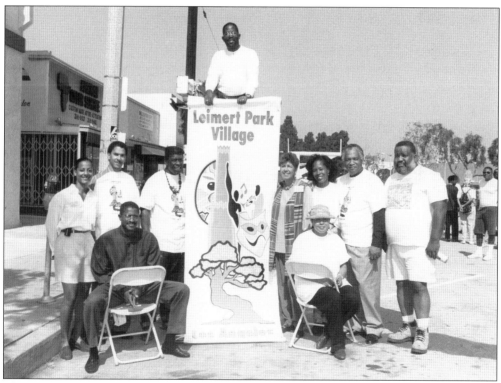

The Leimert Park Village Community Development Corporation (CDC) was created after the 1992 Los Angeles riots to address community concerns regarding blight and neglect in the inner city. This photograph shows the executive board members of the CDC at a "Street Scape Ground Breaking Ceremony" with Eighth District council representative Mark Ridley-Thomas (at podium) in Leimert Park. (Courtesy of the Kwame Cooper collection.)

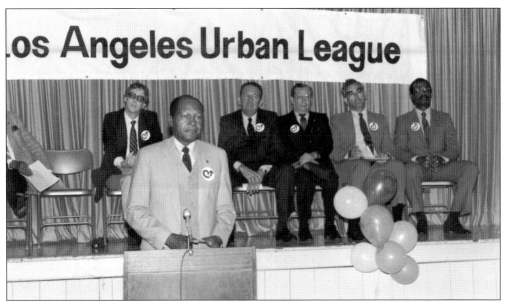

Photographed for the Los Angeles Urban League event, Tim and Walter H. Leimert III now comprise of three generations of the Leimert family in Leimert dating back to 1926. The late Tom Bradley addresses the Los Angeles Urban League at a conference. (Courtesy of Leimert Investment Company.)

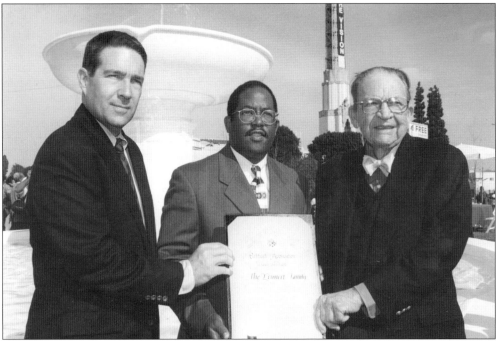

Walter H. Leimert III (left) is photographed with his father, Tim Leimert (right), and Eight District councilman Mark Ridley-Thomas (center) in January 2000 in front of the Park Fountain. The Leimert family has been recognized by the State of California for being in business for more than 75 years. (Courtesy of Leimert Investment Company.)

Leimert Park is home to one of the oldest African American newspapers with a long-standing reputation for community activism, the *Los Angeles Sentinel*. Published weekly, the newspaper was founded in 1933 by Col. Leon H. Washington for black readers. The newspaper moved from its offices on East Forty-third Place and Central Avenue to its present locale at 3800 Crenshaw Boulevard in 1993. On March 17, 2004, real estate developer and community activist Danny Blakewell purchased the *Los Angeles Sentinel*. Blakewell is pictured here with the newspaper's executive director Brenda Marsh-Mitchell. (Courtesy of the *Los Angeles Sentinel*.)

The *Los Angeles Sentinel* annually hosts the largest street festival in Los Angeles, the Taste of Soul Festival. This event takes place on Crenshaw Boulevard between Martin Luther King Jr. Boulevard and Rodeo Road. (Courtesy of the *Los Angeles Sentinel*.)

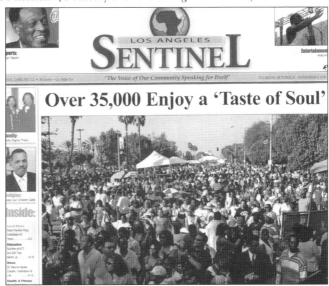

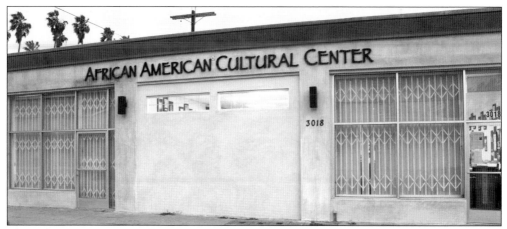

The African American Cultural Center (AACC), founded by Dr. Maulana Karenga in 1965, is pictured here. Located in close proximity to Leimert Park at 3018 West Forty-eighth Street, AACC is the International headquarters of Kwanzaa. The center's activities include lectures and forums on critical and current issues, Kwanzaa workshops, art exhibits, performance arts, film presentations, book parties, rites of passage programs, and other cultural programming. (Courtesy of Tiamoyo Karenga.)

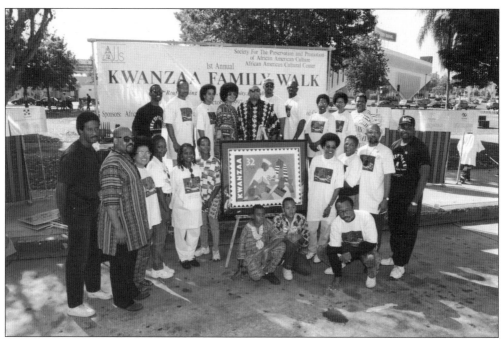

Dr. Maulana Karenga is executive director of the African American Cultural Center. Best known as the creator of Kwanzaa in 1966, an African American and pan-African holiday, Dr. Karenga has played a major role in black intellectual and political culture since the 1960s, especially black studies and social movements. This photograph with Dr. Karenga standing second to the far right shows the 1997 Kwanzaa Celebration Walk; it was taken in Leimert Park Plaza with other community organizations. (Photo Courtesy of Us Archives.)

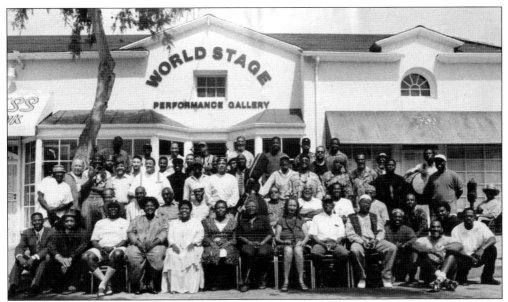

On May 18, 1996, this photograph was taken in tribute to the late great jazz drummer Billy Higgins. Titled *Leimert Park Cultural Renaissance Classic Photo*, this session was the first of a 10-part series that pays tribute to unsung artists and regular individuals who contributed to the forward movement of society, particularly African American causes. This event was the most important gathering of artists in the history of Leimert Park. (Courtesy of Andrew Caudillo.)

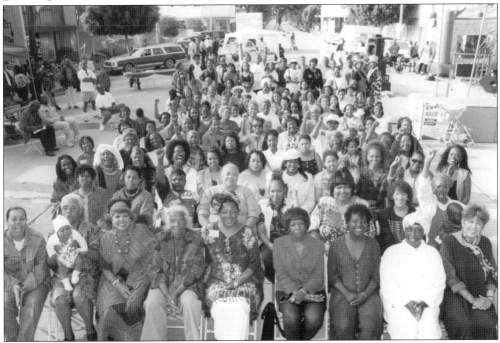

This 1997 photograph, entitled *Black Women: Mothers of Humanity*, was taken along Degnan Boulevard during the annual Malcolm X Festival. These women represented mothers, sisters, daughters, businesswomen, educators, and others who helped raised and educate their children. During this event, Congresswoman Maxine Waters was honored. (Courtesy of Sabir Majeed.)

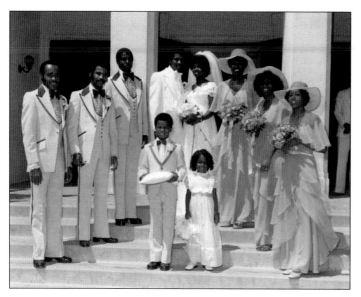

Bille J. Ward, of Seminole and African American descent, married David W. Frierson on May 1, 1976, in Transfiguration Catholic Church at 2515 West Martin Luther King Jr. Boulevard in Leimert Park. A wedding photograph of the newly married couple and their bridal party was captured on the church steps. The Friersons have resided in Leimert Park for more than 35 years. (Courtesy of the Frierson family collection.)

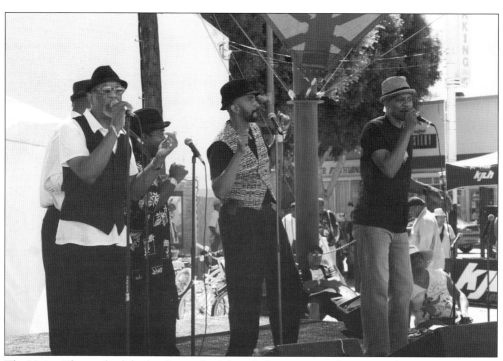

The Vision Theatre back lot has been a backdrop for hosting special events and activities occurring in Leimert Park. Pictured here is the musical group Street Corner Renaissance with founding members, shown left to right, Charles "Sonny" Banks, Kwame Kevin Alexander, Anthony "Tony" Snead, Maurice Kitchen, and Torrence Brannon-Reese. (Courtesy of Sabir Majeed.)

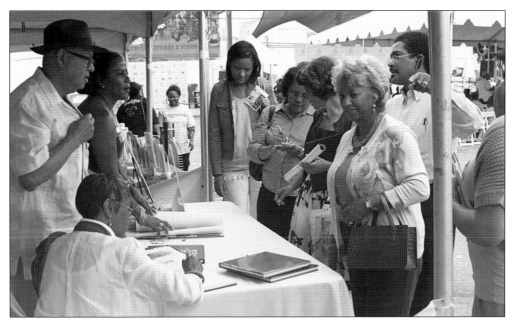

The annual Leimert Park Village Book Fair takes place the last Saturday in June and features over 200 authors, poets, spoken-word artists, and musicians from across the country. Some noted past participants have included poet Nikki Giovanni, actor/author Hill Harper, California poet laureate Al Young, artist Charles Bibbs, Pulitzer Prize winner Douglas A. Blackmon, and actress Kim Wayans, to name a few. Pictured are authors and art historians Dr. Bernard W. and Shirley Kinsey signing copies of their *Kinsey Collection* publication. (Courtesy of Juan Roberts.)

In keeping with Leimert Park's rich creative arts tradition, a monthly Leimert Park Art Walk was established in 2010. Taking place on the last Sunday of every month, the art walk is a free self-guided art and community experience bringing together visual and performance art along Forty-third Place between Leimert and Crenshaw Boulevards. (Courtesy of Ben Caldwell.)

Owned and operated by James Fugate and Tom Hamilton, Eso Won Bookstore moved to Leimert Park in 2006. The bookstore, located at 4327 Degnan Boulevard, carries popular and out-of-print books related to African American life. The bookstore has also hosted book signings by Presidents Barack Obama and Bill Clinton and authors such as Toni Morrison, Walter Mosley, and Bill Cosby. Pictured is co-owner James Fugate. (Courtesy of Malcolm Ali.)

Located at 4339 Degnan Boulevard is Aminah's Cultural Clothing and Sistermarket, offering Afrocentric fabric, art, sculptures, artifacts, and gift items. Specializing in creating custom designs for men and women, Queen Aminah Muhammed, seen here holding one of her designs, moved to the Leimert Park in 2009 to open her boutique. (Courtesy of Malcolm Ali.)

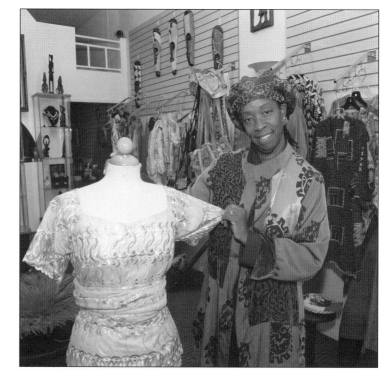

Laura Hendrix opened Gallery Plus in Leimert Park in 1992, just after the Los Angeles riots. Hendrix moved to Leimert Park to help contribute towards the rebuilding of the community and the Leimert Park area. Specializing in print and framing services, the venue also sells artwork, crafts, and holiday items. (Courtesy of the Exum collection.)

The merchants of Leimert Park Village are like family. This photograph of the group was taken at the 53th wedding anniversary celebration of the Manriques. Pictured here, from left to right, are Martin Manrique (of Martin Manrique Custom Drapes and Upholstery), Emma Manrique, Ruth Nuckolls (former owner of Leimert Park Eyewear), and Laura Hendrix (owner of Gallery Plus).

Located at 4334 Degnan Boulevard in Leimert Park is Zambezi Bazaar. Established in 1997, the gift shop sells fine quality gifts, jewelry, and Afrocentric artifacts. This specialty boutique also offers rare books and magazines, out-of-print records, and hard-to-find prints, all of which promote African American culture. Pictured here inside their shop, standing left to right, are siblings Jackie Ryan, Alden Kimbrough, and Mary Kimbrough. (Courtesy of Malcolm Ali.)

A testament to the area's reputation for cultural diversity, Ackee Bamboo Jamaican Cuisine, located at 4305 Degnan Boulevard, brings authentic Jamaican cuisine to the heart of Leimert Park. Family-owned-and-operated by the Beckford family, this local favorite serves scrumptious and delectable Jamaican and soul food specialties. Pictured inside their restaurant are owners Marlene and Delroy Beckford. (Courtesy of Malcolm Ali.)

Phillips BBQ, owned and operated by Foster Phillips is rumored to have the best barbecue in Los Angeles. This small, hole-in-the-wall, take-out-only joint is tucked away in a small mini-complex in Leimert Park. Opened since 1980 this eatery is local favorite among residents and visitors alike. (Courtesy of Exum Collection.)

The Barbara Morrison Performing Arts Center presents live jazz, music, blues, tributes to the legends of jazz, and more. Founded by Los Angeles jazz great Barbara Morrison (pictured), the center features performances by veterans of jazz music as well as up-and-coming stars from around Southern California. (Courtesy of Malcolm Ali.)

Pictured are Sika Wilkerson and Amaechina Doreen Haywood, cofounders and coproducers of the Annual Leimert Park Village African Art and Music Festival that takes place over Labor Day weekend. Sike is a master jeweler and owner of Sika's Fine Jewelry, located at 4330 Degnan Boulevard.

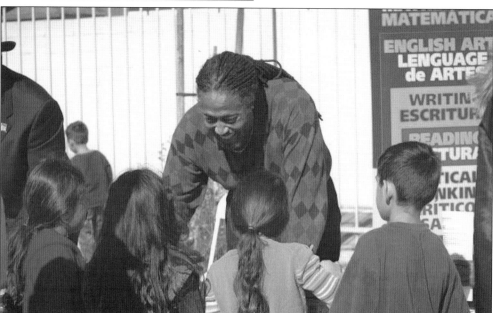

Clarence Williams is the executive director of the We-Can Foundation, located at 4331 Degnan Boulevard in Leimert Park. His foundation provides educational scholarships for inner-city youth as well as academic counseling and financial assistance for school supplies. (Courtesy of the Exum collection.)

Once referring to Leimert Park as the "Black Greenwich Village," film producer, writer, and director John Singleton has been a longtime supporter of Leimert Park. Singleton's offices are located on Degnan Boulevard in Leimert Park. He has also filmed several of his projects in and around the area, including his breakout and now classic 1991 drama *Boyz N the Hood*, starring Cuba Gooding Jr., Laurence Fishburne, and Ice Cube. This movie's success made Singleton the first black and the youngest ever Oscar nominee for directing, at the age of 24. His other productions filmed in Leimert Park include *Baby Boy*, with Tyrese Gibson and Taraji P. Henson. (Courtesy of Mayme A. Clayton Library and Museum Collection.)

Pictured are members of the Cherrywood/Leimert Block Club. This club, founded in the early 1980s by Mr. and Mrs. Calvin McKinney of Cherrywood Avenue, provides residents an opportunity to address issues and concerns affecting their neighborhood and a platform to control the quality of life in their community. Community unity is further enhanced through social events such as a summer barbecue party and a Christmas party. The boundaries of the club are roughly Rodeo Road on the north, Martin Luther King Jr. Boulevard on the south, Arlington Avenue on the east, and Crenshaw Boulevard on the west. (Courtesy of Billie Frierson.)

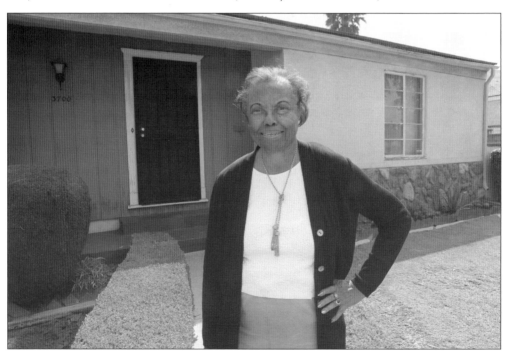

Ernestine Huff is shown here in front of her two-bedroom, one-bathroom home on Olmsted Avenue. She has lived in Leimert Park with her family since 1975. Ernestine is also an active member of the Leimert Park/Cherrywood Block Club (seen above) as well as Our Author's Study Club, Inc. (Courtesy of Malcolm Ali.)

Pictured here is Lorna Borja who moved into her Early Colonial/ Spanish–style duplex in 2002. Her residence has three bedrooms and two bathrooms. (Courtesy of James Sumbi.)

David Miller is pictured here standing outside his Colonial Georgian–style, two-story home on Hepburn Avenue. The home consists of five bedrooms, two bathrooms, and more than 2,500 square feet of living space. Miller is the chief operating officer and co-owner/cofounder of Our Weekly Los Angeles Newspaper Group. Miller, his wife, Paula, and their family have lived in this residence since 1994. (Courtesy of the Malcolm Ali.)

James Sumbi, his wife, Christine, and daughter Imani stand n front of their three-bedroom, two-bathroom Early Colonial/ Spanish–style duplex. The family moved into their home in 2005 and has lived in Leimert Park for eight years. (Courtesy of James Sumbi.)

Shoji Kodani and Shiori Kodani are pictured here in front of their two-story Bronson Avenue home, located directly across the street from the Crenshaw Square Center. They have lived in Leimert Park since 1979. Their home was built in 1949 and was designed by a Japanese architect.

Ten

THE FUTURE OF
LEIMERT PARK

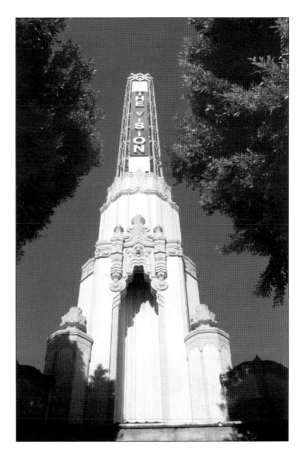

A new generation of redevelopment is on the horizon for Leimert Park. Baldwin Hills Crenshaw Plaza, underwent a $35-million renovation. Kaiser Permanente will follow suit with the construction of a multi-million-dollar medical office. Many new restaurants, retailers, performing arts, and entertainment venues have settled in as Leimert Park once again reinvents itself for the 21st century. Shown here is the historic Vision Theatre undergoing a multi-million-dollar renovation by the California Cultural Historic Endowment. It is expected to open its doors again in 2012. (Courtesy of the Exum collection.)

The community joins Tim Leimert in the construction of Krispy Kreme Doughnuts at Leimert Park on Walter H. Leimert Company soil in 2000. (Courtesy of Leimert Investment Company.)

Councilman Bernard C. Parks is pictured breaking ground for the new Mouton Square Shopping Complex, which will be built at Martin Luther King Jr. and Crenshaw Boulevards. This project is expected to cost $5 million and generate 1,000 new jobs for the area of Leimert Park and Crenshaw. (Courtesy of the Exum collection.)

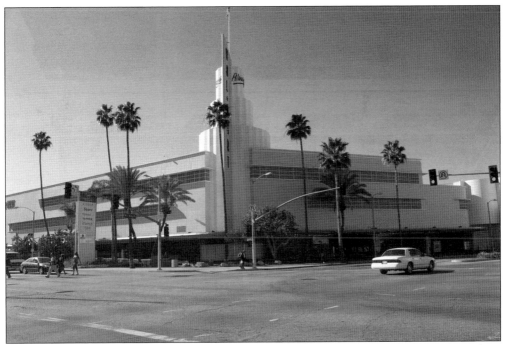

In 2011, Capri Capital Partners completed renovation and remodeling of the two-story Crenshaw Baldwin Hills Shopping Plaza. Remodeling designs included the installation of new interior embellishments, a modern food court, a new bridge linking two major department stores—Walmart and Macy's—and upgraded escalators and elevators. Across the street below, the Broadway Department store has been replaced by Walmart. The image below shows the new bridge that connects to the renovated Macy's departments. This was also the former site of the Sunset Fields Golf Course. (Both, courtesy of Exum collection.)

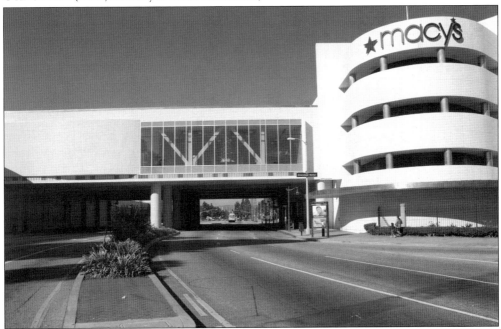

New restaurants have emerged in Leimert Park, including the Post & Beam Restaurant, opened by chef Govind Armstrong and Brad Johnson. Located in the Crenshaw Baldwin Hills Shopping Center, this upscale restaurant provides another great location to eat in the district. (Courtesy of the Exum collection.)

Television personality, authors and entrepreneur Tavis Smiley operates his business at 4434 Crenshaw Boulevard, directly across the street from the Leimert Park Square Plaza. Also housed at this administrative office is the Sheryl Flowers Radio Studio, where he broadcasts his weekly one-hour program called Smiley & West with Dr. Cornell West. The show features interviews with newsmakers, leaders, and artists. (Courtesy of the Exum collection.)

On April 28, 2012, the long-awaited Metro Expo Exposition Rail had its grand-opening and construction is now underway for an eight-and-a-half-mile Metro Expo Crenshaw Rail that will pass by the Baldwin Hills Crenshaw Plaza. Many businesses along the Crenshaw corridor ardently support placing an expo stop at Leimert Park Village, which would bring thousands of visitors, tourists, and residents from the surrounding area to Leimert Park (Courtesy of Exum Collection.)

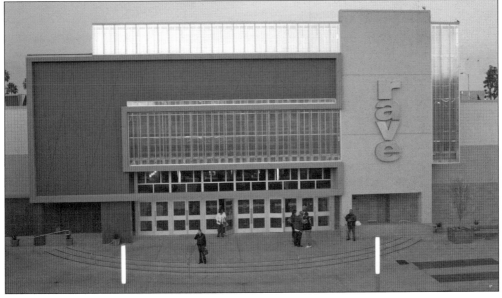

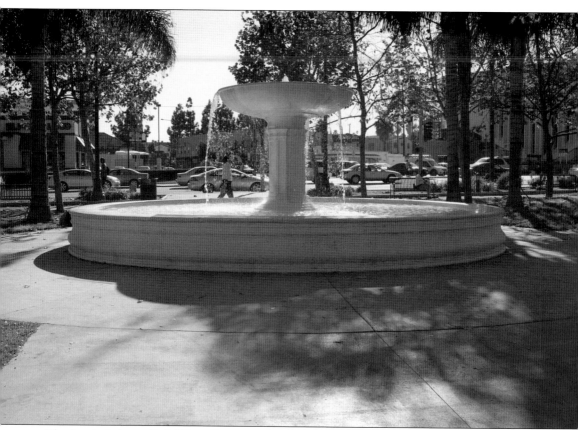

The iconic Leimert Park Water Fountain was the first structure built in the park. It still stands today as a symbol of the grandeur envisioned by its founders and of the significance, beauty, and fortitude of the historic community that surrounds it. (Courtesy of the Exum collection.)

BIBLIOGRAPHY

Baker, Harrison R. *Subdivision Principles and Practice*. Los Angeles: The Real Estate Institute of the California Real Estate Association at University of Southern California, 1936.

Davis, Mike. *City of Quartz: Excavating the Future in Los Angeles*. London: Vintage Publisher, 1990.

Darnell, Hunt. *Black Los Angeles: American Dreams, Racial Realities*. New York: NYU Press, 2010.

Findling, John E., and Kimberly D. Pelle. *Encyclopedia of the Modern Olympic Movement*. Westport, CT: Greenwood Press, 2004.

Harris, Peter J. "Leimert Park Village." *American Visions* 7, no. 3 (June/July 1992): 36.

Henry, Bill, and Patricia Henry Yeomans. *Bill Henry: An Approved History of the Olympic Games*. Los Angeles: Southern California Committee for the Olympic Games, 1984.

Hise, Greg. " 'Nature's workshop:' Industry and Urban Expansion in Southern California, 1900–1950." *Journal of Historical Geography*, 27, no. 1 (2001): 74–92.

Kurashige, Scott. *The Shifting Grounds of Race*. Princeton: Princeton University Press, 2008.

Lautner, Harold W. *Subdivision Regulations: An Analysis of Land Subdivision Control Practices*. Chicago: Public Administration Service, 1941.

Nelson, Richard L., and Frederick T. Aschman. *Real Estate and City Planning*. Englewood Cliffs, NJ: Prentice-Hall, Inc., 1957.

Schiesl, Martin, and Mark M. Dodge, eds. *City of Promise: Race and Historical Change in Los Angeles*. Claremont, CA: Regina Books, 2006.

Smith, R.J. *The Great Black Way: LA in the 1940s and the Lost African-American Renaissance*. New York: Public Affairs Publishers, 2006.

Uchima, Ansho Mas, and Minoru Shinmoto. *Seinan–Southwest Los Angeles: Stories and Experiences from Residents of Japanese Ancestry*. Los Angeles: Nikkei Writers Guild, 2010.

DISCOVER THOUSANDS OF LOCAL HISTORY BOOKS FEATURING MILLIONS OF VINTAGE IMAGES

Arcadia Publishing, the leading local history publisher in the United States, is committed to making history accessible and meaningful through publishing books that celebrate and preserve the heritage of America's people and places.

Find more books like this at
www.arcadiapublishing.com

Search for your hometown history, your old stomping grounds, and even your favorite sports team.

Consistent with our mission to preserve history on a local level, this book was printed in South Carolina on American-made paper and manufactured entirely in the United States. Products carrying the accredited Forest Stewardship Council (FSC) label are printed on 100 percent FSC-certified paper.

MADE IN THE USA